Praise for

No Time to Spare

"The trivially personal is a chief pleasure of this collection . . . The pages sparkle with lines that make a reader glance up, searching for an available ear with which to share them . . . 'Words are my skein of yarn, my lump of wet clay, my block of uncarved wood,' [Le Guin] explains, and then quietly astounds us with the carving."

—Melissa Febos, *New York Times Book Review*

"Delightful . . . inquisitive and stroppily opinionated in equal measure . . . The sentences are perfectly balanced and the language chosen with care. After all, she writes, 'Words are my matter—my stuff.' And it's through their infinite arrangements . . . that Ms. Le Guin's extraordinary imaginary worlds have been built and shared."

—*Wall Street Journal*

"Witty, often deeply observed . . . Le Guin has a well-ordered mind . . . Engagingly mindful of everything around her." —*USA Today*

"There are shades of Adrienne Rich here . . . At the end of *No Time to Spare*, having enjoyed all the Annals of Pard and the Steinbeck anecdotes, the stories about the Oregon desert and the musings on belief, all I could think was: I want Le Guin to keep going, on and on. I want to read more." —Michelle Dean, *Los Angeles Times*

"Might there be truth to the commonplace that science-fiction writers are prophets? . . . A year ago I argued that Le Guin deserved a Nobel Prize in literature. In fact—what a fantasy!—she ought to be running the country." —*Washington Post*

"The pages pop with life, even as Le Guin, ever sassy, reckons with the toils of aging . . . The best bits are the interludes for Pard, her new black-and-white cat. Young when she's old, spry when she's stiff, he exists in twinkling counterpoise—especially when he's time-traveling through her whirring external hard drive to, Le Guin suspects, cosmic parts unknown."
—*Wired*

"Le Guin shows that elders have plenty to teach . . . [She] finds inspiration in the everyday and makes it sparkle with her prose . . . In step with her legacy, [she] challenges us to reconsider what we automatically accept . . . [*No Time to Spare*] will leave readers hoping that Le Guin is given a bit more time to share her observations—on aging, art, our world—and to remind us of things we mustn't forget." —*Newsday*

"Erudite, witty and . . . wise . . . [Le Guin] makes the reader continually conscious of the ways that her age is a part of her life. That subtle coherence gives the book a special feeling, to borrow her words . . . a 'steady, luminous ethical focus' . . . Deep down there: that is where Le Guin has taken readers for decade after decade, and where, these essays show, she is capable of taking them still." —*Chicago Tribune*

"The surprising and satisfying culmination to a career in other literary forms . . . Even in the familiar relationship of an old woman and her cat, Le Guin finds an ambit for challenging moral insight and matter for an inquisitiveness that probes the deep time of evolution . . . It is a comfort to know, as reality seems to grow more claustrophobic and inescapable, that she remains at her desk, busily subverting our world."
—*New Republic*

"Clever observations and sharp, nimble prose provide a window into the interior life of the award-winning novelist." —*Harper's Bazaar*

"The more you reread this collection of blog posts by science-fiction grandmaster Le Guin, the more you're convinced of Oliver Wendell Holmes's quip that for the true thinker, nothing is trivial . . . [*No Time to Spare*] is delivered in the core-drilling, clear, thoughtful language of somebody who's been crafting English for more than half a century."

— *Christian Science Monitor*

"Each entry is filled with warmth, insight, and humor." — *Real Simple*

"Altogether fantastic . . . A magnificent read in its tessellated totality."

— *Brain Pickings*

"Le Guin's mindful empathy for every kind of living and nonliving thing makes her a role model for the rest of us." — *PopMatters*

"[Le Guin is] a natural storyteller . . . These snippets from her life are inarguably delightful." — *BookPage*

"Serious wisdom about our world, politics, literature, aging, and more."

— *Book Riot*

"A bit like having a one-way conversation with a funny, cranky, keen-eyed old friend . . . Even when you want to quibble with her, Le Guin keeps you thoroughly engaged . . . She has a knack for stepping back from life on earth and seeing it for the strange thing it is." — *Oregonian*

"[There's] a welcome lightheartedness to this serious and morally weighty collection. It is a book that truly does matter."

— *Houston Chronicle*

"Rife with insight [and] humor." — *Columbus Dispatch*

"Following Le Guin's penetrating mind as she thinks about the problems of our world and puzzles of language makes *No Time to Spare* a more than worthwhile read for fans and new readers alike."

—*Riveter*

"Le Guin is a thoughtful and careful writer, and so her opinions are thoughtfully and carefully organized. She knows what she thinks, and she writes so well that you'll want to return to these candid essays ... like returning to an older, wiser friend."

—*Omnivoracious*

"Sharp-eyed, bighearted, idiosyncratic and highly enjoyable ... Both Le Guin's eye for detail and her dry wit are on full display here ... Readers will find much to think about in this wise and eloquent collection."

—*Shelf Awareness*

"Invite[s] close reading, which always reaps rich rewards, the true gift of this lovely book."

—*Booklist*

"Spirited, wry reflections on aging, literature, and America's moral life ... An entertaining collection ... Thoughtful musings from a deft and sharply insightful writer."

—*Kirkus Reviews*

"Short, punchy, and canny meditations on aging, literature, and cats ... [Le Guin] offers her many fans a chance to share her clear-eyed experience of the everyday."

—*Publishers Weekly*

NO TIME TO SPARE

Selected Books by Ursula K. Le Guin

FICTION

POETRY

Finding My Elegy
Wild Angels
Walking in Cornwall (chapbook)
Tillai and Tylissios (with Theodora Kroeber; chapbook)
Hard Words
In the Red Zone (with Henk Pander; chapbook)
Wild Oats and Fireweed
No Boats (chapbook)
Blue Moon over Thurman Street
Going Out with Peacocks
Sixty Odd

TRANSLATIONS

Lao Tzu: Tao Te Ching
Selected Poems of Gabriela Mistral

No Time to Spare

THINKING ABOUT WHAT MATTERS

Ursula K. Le Guin

Mariner Books
Houghton Mifflin Harcourt
BOSTON NEW YORK

First Mariner Books edition 2019
Copyright © 2017 by Ursula K. Le Guin
Introduction copyright © 2017 by Karen Joy Fowler

For information about permission to reproduce selections from this book,
write to trade.permissions@hmhco.com or to Permissions,
Houghton Mifflin Harcourt Publishing Company,
3 Park Avenue, 19th Floor, New York, New York 10016.

hmhco.com

Library of Congress Cataloging-in-Publication Data is available.
ISBN 978-1-328-66159-3
ISBN 978-1-328-50797-6 (pbk.)

Book design by Martha Kennedy

Printed in the United States of America
DOC 10 9 8 7 6 5 4 3 2 1

The illustration on page 154 is by the author.

To Vonda N. McIntyre, with love

Contents

THE ANNALS OF PARD

PART THREE: TRYING TO MAKE SENSE OF IT

THE ANNALS OF PARD

PART FOUR: REWARDS

Introduction

MANY YEARS AGO I recall seeing a cartoon in *The New Yorker*. Two men, one a seeker, the other a sage, sit on a ledge in front of a mountain cave, surrounded by cats. "The meaning of life is cats," the sage is telling the seeker. Thanks to the magic of the Internet, I can pinpoint the year of publication as 1996 and the cartoonist as Sam Gross.

The cartoon came back into my mind while reading this collection. I thought that if I climbed the mountain up to the cave of the wise Ursula Le Guin and posed the predictable question, I might get this very same answer. Or not. Le Guin is not predictable. She might say instead that "old age is for anyone who gets there." Or that "fear is seldom wise and never kind." Or she might tell me that "the grave is without egg."

For the seeker, the answer is less important than what the seeker does with the answer. I don't know what the important part is for the sage. Le Guin suggests that it just might be breakfast.

Today the trip to the Le Guin cave is less arduous but no less dangerous than the archetypal climb to the mountaintop. You must cross the Wikipedian swamp, with its uncertain footing. Tiptoe by any and all comments sections so as not to wake the

trolls. Remember, if you can see them, they can see you! Avoid the monster YouTube, that great eater of hours. Make your way instead to the wormhole known as Google and slide on through. Land at Ursula Le Guin's website and go directly to the blog to see her most recent postings.

But first read this book.

Here you will find an archive of meditations on many things: aging; exorcism; the need for ritual, especially when performed without specific belief; how a mistake on the Internet can never be corrected; live music and literate children; Homer, Sartre, and Santa Claus. Le Guin is not the sort of sage who demands agreement and obeisance. Anyone who has ever read her books knows this. The musings that follow merely show you what she herself has been thinking about.

But all function beautifully as launchings into your own thoughts. Sometimes the shingle on the cave says that the sage is out. On these occasions, the topic of the day is proposed by Cat instead. "Think about beetles," Cat suggests, and so I do. Thinking about beetles proves surprisingly expansive, especially when told to do so by the good cat with the bad paws. I think about cats and their adorable murderous ways. I think about the troubled human/other interface. Somewhere inside us, I think, we all carry the Mowgli dream—that the other animals will see and accept us as one among them. And then we fail this dream when the wrong animals ask it of us. We think we wish to join the wild animals in the jungle but will not tolerate the wild animals in our kitchens. There are too many ants, we think, reaching for the spray, when it is equally true that there are too many humans.

In another essay, in another book, Le Guin has said that

so-called realism centers the human. Only the literature of the fantastic deals with the nonhuman as of equal interest and importance. In this and so many other ways, fantasy is the more subversive, the more comprehensive, the more intriguing literature. These two issues combined — our inability to deal with our own numbers and our insistence that we are what matters most — may well be the finish of us. And with these thoughts, I arrive at the end of the world, where I tire finally of thinking about beetles and go back to thinking about Le Guin.

For all the decades of her career, Le Guin has been defending the imagination and all the stories that rise from it. I myself have been finding my way up the mountain my entire adult life, to get her answers to questions I didn't even know I was asking. Since I am now headed toward seventy, this is a long time. I count among the world's great gifts to me the fact that I know her personally, that I've spent many hours in her company. But if I only (only! ha!) had the books, the gift would still be such a great one.

I think that she's currently having a moment, a moment of recognition and appreciation. This particular moment (she's had others) is partly about her deep, foundational impact on a generation of writers like me. At the beginning of this collection, she speaks of discovering José Saramago's blog and thinking, Oh, I see! Can I do it too? Which is precisely how her own work has functioned for so many of us as an example, a freeing from convention and expectation, an invitation into a larger world than the one we see.

But to my mind, all of Le Guin's moments, all the recognition and admiration, fall short of her actual accomplishments. I can think of no other writer in the entirety of history who has

created the number of worlds that she has, never mind their complexity and intricacy. Where other writers secure their legacy with a single book, she's written a dozen worthy of that. And her very last novel, *Lavinia,* is surely among her great works. She has been both prolific and potent. She has been both playful and powerful. She has, in her life and her work, always been a force for good, an acute social critic, necessary more now than ever as we watch the evil turn the world is taking. We who followed her both as readers and writers are the lucky ones. We not only love her; we need her.

What you will find in these pages here is a more casual Le Guin, a Le Guin at home. Some of the issues that have obsessed her throughout her career—the fatal model of growth capitalism; sisterhood and the ways in which it differs from the male fraternal; the denigration and misunderstandings of genre, science, and belief—continue to appear, but they've been sanded back to their absolute essentials. It is particularly pleasurable here to watch the lively way her mind works, and how a posting whose trappings initially seem merely sportive becomes deeply consequential.

Le Guin has always been marvelous on the natural world. She is one of the most noticing people I've ever met, always paying attention to the birdsong in the background, the leaf on the tree. Her essay here on the rattlesnake and then the one about the lynx work on me like poetry, sparking expanding emotions I can't quite identify or have no words for.

I should make up the words! Le Guin would. (Google "Fibble, Game of.") So I should say that when I read Le Guin writing about birds or beasts, about particular animals with histories and personalities and singular behaviors, or when I read

Le Guin on trees and rivers and all the vanishing beauties of the world, I feel transpaced. I feel other-awed. I feel tongue-gaped.

Tongue-gapedly,
KAREN JOY FOWLER

A Note at the Beginning

October 2010

I'VE BEEN INSPIRED by José Saramago's extraordinary blogs, which he posted when he was eighty-five and eighty-six years old. They were published this year in English as *The Notebooks*. I read them with amazement and delight.

I never wanted to blog before. I've never liked the word *blog* — I suppose it is meant to stand for *bio-log* or something like that, but it sounds like a sodden tree trunk in a bog, or maybe an obstruction in the nasal passage (Oh, she talks that way because she has such terrible blogs in her nose). I was also put off by the idea that a blog ought to be "interactive," that the blogger is expected to read people's comments in order to reply to them and carry on a limitless conversation with strangers. I am much too introverted to want to do that at all. I am happy with strangers only if I can write a story or a poem and hide from them behind it, letting it speak for me.

So though I have contributed a few bloglike objects to Book View Café, I never enjoyed them. After all, despite the new name, they were just opinion pieces or essays, and writing essays has always been tough work for me and only occasionally rewarding.

But seeing what Saramago did with the form was a revelation.

Oh! I get it! I see! Can I try too?

My trials/attempts/efforts (that's what *essays* means) so far have very much less political and moral weight than Saramago's and are more trivially personal. Maybe that will change as I practice the form, maybe not. Maybe I'll soon find it isn't for me after all, and stop. That's to be seen. What I like at the moment is the sense of freedom. Saramago didn't interact directly with his readers (except once). That freedom, also, I'm borrowing from him.

Part One

GOING OVER EIGHTY

In Your Spare Time

October 2010

I GOT A questionnaire from Harvard for the sixtieth reunion of the Harvard graduating class of 1951. Of course my college was Radcliffe, which at that time was affiliated with but wasn't considered to *be* Harvard, due to a difference in gender; but Harvard often overlooks such details from the lofty eminence where it can consider all sorts of things beneath its notice. Anyhow, the questionnaire is anonymous, therefore presumably gender-free; and it is interesting.

The people who are expected to fill it out are, or would be, almost all in their eighties, and sixty years is time enough for all kinds of things to have happened to a bright-eyed young graduate. So there's a polite invitation to widows or widowers to answer for the deceased. And Question 1c, "If divorced," gives an interesting set of little boxes to check: Once, Twice, Three times, Four or more times, Currently remarried, Currently living with a partner, None of the above. This last option is a poser. I'm trying to think how you could be divorced and still none of the above. In any case, it seems unlikely that any of those boxes would have

been on a reunion questionnaire in 1951. You've come a long way, baby! as the cigarette ad with the bimbo on it used to say.

Question 12: "In general, given your expectations, how have your grandchildren done in life?" The youngest of my grandchildren just turned four. How has he done in life? Well, very well, on the whole. I wonder what kind of expectations you should have for a four-year-old. That he'll go on being a nice little boy and learn pretty soon to read and write is all that comes to my mind. I suppose I'm supposed to expect him to go to Harvard, or at least to Columbia like his father and great-grandfather. But being nice and learning to read and write seem quite enough for now.

Actually, I don't exactly have expectations. I have hopes, and fears. Mostly the fears predominate these days. When my kids were young I could still hope we might not totally screw up the environment for them, but now that we've done so, and are more deeply sold out than ever to profiteering industrialism with its future-horizon of a few months, any hope I have that coming generations may have ease and peace in life has become very tenuous, and has to reach far, far forward into the dark.

Question 13: "What will improve the quality of life for the future generations of your family?"—with boxes to rank importance from 1 to 10. The first choice is "Improved educational opportunities"—fair enough, Harvard being in the education business. I gave it a 10. The second is "Economic stability and growth for the U.S." That stymied me totally. What a marvelous example of capitalist thinking, or nonthinking: to consider growth and stability as the same thing! I finally wrote in the margin, "You can't have both," and didn't check a box.

The rest of the choices are: Reduction of the U.S. debt, Reduced dependence on foreign energy, Improved health-care quality and cost, Elimination of terrorism, Implementation of

an effective immigration policy, Improved bipartisanship in U.S. politics, Export democracy.

Since we're supposed to be considering the life of future generations, it seems a strange list, limited to quite immediate concerns and filtered through such current right-wing obsessions as "terrorism," "effective" immigration policy, and the "exportation" of "democracy" (which I assume is a euphemism for our policy of invading countries we don't like and trying to destroy their society, culture, and religion). Nine choices, but nothing about climate destabilization, nothing about international politics, nothing about population growth, nothing about industrial pollution, nothing about the control of government by corporations, nothing about human rights or injustice or poverty . . .

Question 14: "Are you living your secret desires?" Floored again. I finally didn't check Yes, Somewhat, or No, but wrote in "I have none, my desires are flagrant."

But it was Question 18 that really got me down. "In your spare time, what do you do? (check all that apply)." And the list begins: "Golf . . ."

Seventh in the list of twenty-seven occupations, after "Racquet sports" but before "Shopping," "TV," and "Bridge," comes "Creative activities (paint, write, photograph, etc.)."

Here I stopped reading and sat and thought for quite a while.

The key words are *spare time*. What do they mean?

To a working person — supermarket checker, lawyer, highway crewman, housewife, cellist, computer repairer, teacher, waitress — spare time is the time not spent at your job or at otherwise keeping yourself alive, cooking, keeping clean, getting the car fixed, getting the kids to school. To people in the midst of life, spare time is free time, and valued as such.

But to people in their eighties? What do retired people have but "spare" time?

I am not exactly retired, because I never had a job to retire from. I still work, though not as hard as I did. I have always been and am proud to consider myself a working woman. But to the Questioners of Harvard my lifework has been a "creative activity," a hobby, something you do to fill up spare time. Perhaps if they knew I'd made a living out of it they'd move it to a more respectable category, but I rather doubt it.

The question remains: When all the time you have is spare, is free, what do you make of it?

And what's the difference, really, between that and the time you used to have when you were fifty, or thirty, or fifteen?

Kids used to have a whole lot of spare time, middle-class kids anyhow. Outside of school and if they weren't into a sport, most of their time was spare, and they figured out more or less successfully what to do with it. I had whole spare summers when I was a teenager. Three spare months. No stated occupation whatsoever. Much of after-school was spare time too. I read, I wrote, I hung out with Jean and Shirley and Joyce, I moseyed around having thoughts and feelings, oh lord, deep thoughts, deep feelings . . . I hope some kids still have time like that. The ones I know seem to be on a treadmill of programming, rushing on without pause to the next event on their schedule, the soccer practice the playdate the whatever. I hope they find interstices and wriggle into them. Sometimes I notice that a teenager in the family group is present in body — smiling, polite, apparently attentive — but absent. I think, I hope she has found an interstice, made herself some spare time, wriggled into it, and is alone there, deep down there, thinking, feeling.

The opposite of spare time is, I guess, occupied time. In my

case I still don't know what spare time is because all my time is occupied. It always has been and it is now. It's occupied by living.

An increasing part of living, at my age, is mere bodily maintenance, which is tiresome. But I cannot find anywhere in my life a time, or a kind of time, that is unoccupied. I am free, but my time is not. My time is fully and vitally occupied with sleep, with daydreaming, with doing business and writing friends and family on email, with reading, with writing poetry, with writing prose, with thinking, with forgetting, with embroidering, with cooking and eating a meal and cleaning up the kitchen, with construing Virgil, with meeting friends, with talking with my husband, with going out to shop for groceries, with walking if I can walk and traveling if we are traveling, with sitting Vipassana sometimes, with watching a movie sometimes, with doing the Eight Precious Chinese exercises when I can, with lying down for an afternoon rest with a volume of Krazy Kat to read and my own slightly crazy cat occupying the region between my upper thighs and mid-calves, where he arranges himself and goes instantly and deeply to sleep. None of this is spare time. I can't spare it. What is Harvard thinking of? I am going to be eighty-one next week. I have no time to spare.

The Sissy Strikes Back

November 2010

I'VE LOST FAITH in the saying "You're only as old as you think you are," ever since I got old.

It is a saying with a fine heritage. It goes right back to the idea of the Power of Positive Thinking, which is so strong in America because it fits in so well with the Power of Commercial Advertising and with the Power of Wishful Thinking, aka the American Dream. It is the bright side of Puritanism: What you deserve is what you get. (Never mind just now about the dark side.) Good things come to good people and youth will last forever for the young in heart.

Yup.

There is a whole lot of power in positive thinking. It is the great placebo effect. In many cases, even dire cases, it works. I think most old people know that, and many of us try to keep our thinking on the positive side as a matter of self-preservation, as well as dignity, the wish not to end with a prolonged whimper. It can be very hard to believe that one is actually eighty years old, but as they say, you'd better believe it.

I've known clear-headed, clear-hearted people in their nineties. They didn't think they were young. They knew, with a patient, canny clarity, how old they were. If I'm ninety and believe I'm forty-five, I'm headed for a very bad time trying to get out of the bathtub. Even if I'm seventy and think I'm forty, I'm fooling myself to the extent of almost certainly acting like an awful fool.

Actually, I've never heard anybody over seventy say that you're only as old as you think you are. Younger people say it to themselves or each other as an encouragement. When they say it to somebody who actually is old, they don't realize how stupid it is, and how cruel it may be. At least there isn't a poster of it.

But there is a poster of "Old age is not for sissies" — maybe it's where the saying came from. A man and a woman in their seventies. As I remember it, they both have what the air force used to call the Look of Eagles, and are wearing very tight-fitting minimal clothing, and are altogether very fit. Their pose suggests that they've just run a marathon and aren't breathing hard while they relax by lifting sixteen-pound barbells. Look at us, they say. Old age is not for sissies.

Look at me, I snarl at them. I can't run, I can't lift barbells, and the thought of me in tight-fitting minimal clothing is appalling in all ways. I am a sissy. I always was. Who are you jocks to say old age isn't for me?

Old age is for anybody who gets there. Warriors get old; sissies get old. In fact it's likely that more sissies than warriors get old. Old age is for the healthy, the strong, the tough, the intrepid, the sick, the weak, the cowardly, the incompetent. People who run ten miles every morning before breakfast and people who

live in a wheelchair. People who work the London *Times* cross-word in ink in ten minutes and people who can't quite remember who the president is just now. Old age is less a matter of fitness or courage than of luck equals longevity.

If you eat your sardines and leafy greens and wear SPF 150 and develop your abs and blabs and slabs or whatever they are in order to live a long life, that's good, and maybe it will work. But the longer a life is, the more of it will be old age.

The leafy greens and the workouts may well help that old age to be healthy, but unfair as it may be, nothing guarantees health to the old. Bodies wear out after a certain amount of mile-age despite the most careful maintenance. No matter what you eat and how grand your abs and blabs are, still your bones can let you down, your heart can get tired of its incredible nonstop lifelong athletic performance, and there's all that wiring and stuff inside that can begin to short-circuit. If you did hard physi-cal labor all your life and didn't really have the chance to spend a lot of time in gyms, if you ate mostly junk food because it's all you knew about and all you could afford in time and money, if you haven't got a doctor because you can't buy the insurance that stands between you and the doctors and the medicines you need, you may arrive at old age in rather bad shape. Or if you just run into some bad luck along the way, accidents, illnesses, it's the same. You won't be running marathons and lifting weights. You may have trouble getting up the stairs. You may have trou-ble just getting out of bed. You may have trouble getting used to hurting all the time. And it isn't likely to get better as the years go on.

The compensations of getting old, such as they are, aren't in the field of athletic prowess. I think that's why the saying and the

poster annoy me so much. They're not only insulting to sissies, they're beside the point.

I'd like a poster showing two old people with stooped backs and arthritic hands and time-worn faces sitting talking, deep, deep in conversation. And the slogan would be "Old Age Is Not for the Young."

The Diminished Thing

May 2013

NOT WANTING TO know much about getting old (I don't mean older, I mean *old*: late seventies, eighties, beyond) is probably a human survival characteristic. What's the use of knowing anything about it ahead of time? You'll find out enough when you get there.

One of the things people often find when they get there is that younger people don't want to hear about it. So honest conversation concerning geezerhood takes place mostly among geezers.

And when younger people tell old people what old age is, the geezers may not agree but seldom argue.

I want to argue, just a little.

Robert Frost's ovenbird asked the operative question: "What to make of a diminished thing?"

Americans believe strongly in positive thinking. Positive thinking is great. It works best when based on a realistic assessment and acceptance of the actual situation. Positive thinking founded on denial may not be so great.

Everybody who gets old has to assess their ever-changing

but seldom improving situation and make of it what they can. I think most old people accept the fact that they're old—I've never heard anybody over eighty say "I'm not old." And they make the best of it. As the saying goes, consider the alternative!

A lot of younger people, seeing the reality of old age as entirely negative, see acceptance of age as negative. Wanting to deal with old people in a positive spirit, they're led to deny old people their reality.

With all good intentions, people say to me, "Oh, you're not old!"

And the pope isn't Catholic.

"You're only as old as you think you are!"

Now, you don't honestly think having lived eighty-three years is a matter of opinion.

"My uncle's ninety and he walks eight miles a day."

Lucky Unk. I hope he never meets that old bully Arthur Ritis or his mean wife Sciatica.

"My grandmother lives all by herself and she's still driving her car at ninety-nine!"

Well, hey for Granny, she's got good genes. She's a great example—but not one most people are able to imitate.

Old age isn't a state of mind. It's an existential situation.

Would you say to a person paralyzed from the waist down, "Oh, you aren't a cripple! You're only as paralyzed as you think you are! My cousin broke her back once but she got right over it and now she's in training for the marathon!"

Encouragement by denial, however well-meaning, backfires. Fear is seldom wise and never kind. Who is it you're cheering up, anyhow? Is it really the geezer?

To tell me my old age doesn't exist is to tell me I don't exist. Erase my age, you erase my life — me.

Of course that's what a lot of *really* young people inevitably do. Kids who haven't lived with geezers don't know what they are. So it is that old men come to learn the invisibility women learned twenty or thirty years earlier. The kids on the street don't see you. If they have to see you, it's often with the indifference, distrust, or animosity animals feel for animals of a different species.

Animals have instinctive codes of etiquette for avoiding or defusing this mindless fear and hostility. Dogs ceremonially smell each other's anuses, cats ceremonially yowl on the territorial borderline. Human societies provide us with various more elaborate devices. One of the most effective is respect. You don't like the stranger, but your carefully respectful behavior to him elicits the same from him, thus avoiding the sterile expense of time and blood on aggression and defense.

In less change-oriented societies than ours, a great part of the culture's useful information, including the rules of behavior, is taught by the elders to the young. One of those rules is, unsurprisingly, a tradition of respect for age.

In our increasingly unstable, future-oriented, technology-driven society, the young are often the ones who show the way, who teach their elders what to do. So who respects whom for what? The geezers are damned if they're going to kowtow to the twerps — and vice versa.

When there's no social pressure behind it, respectful behavior becomes a decision, an individual choice. Americans, even when they pay pious lip service to Judeo-Christian rules of moral behavior, tend to regard moral behavior as a personal decision, above rules, and often above laws.

This is morally problematic when personal *decision* is confused with personal *opinion*. A decision worthy of the name is based on observation, factual information, intellectual and ethical judgment. Opinion—that darling of the press, the politician, and the poll—may be based on no information at all. At worst, unchecked by either judgment or moral tradition, personal opinion may reflect nothing but ignorance, jealousy, and fear.

So if I "decide"—if my opinion is—that living a long time just means getting ugly, weak, useless, and in the way, I waste no respect on old people, just as if my opinion is that all young people are scary, insolent, unreliable, and unteachable, I waste no respect on them.

Respect has often been overenforced and almost universally misplaced (the poor must respect the rich, all women must respect all men, etc.). But when applied in moderation and with judgment, the social requirement of respectful behavior to others, by repressing aggression and requiring self-control, makes room for understanding. It creates a space where appreciation and affection can grow.

Opinion all too often leaves no room for anything but itself.

People whose society doesn't teach them respect for childhood are lucky if they learn to understand, or value, or even like their own children. Children who aren't taught respect for old age are likely to fear it, and to discover understanding and affection for old people only by luck, by chance.

I think the tradition of respecting age in itself has some justification. Just coping with daily life, doing stuff that was always so easy you didn't notice it, gets harder in old age, till it may take real courage to do it at all. Old age generally involves pain and

danger and inevitably ends in death. The acceptance of that takes courage. Courage deserves respect.

So much for respect. Back to the diminished thing.

Childhood is when you keep gaining, old age is when you keep losing. The Golden Years the PR people keep gloating at us about are golden because that's the color of the light at sunset.

Of course diminishment isn't all there is to aging. Far from it. Life out of the rat race, but still in the comfort zone, can give the chance to be in the moment, and bring real peace of mind.

If memory remains sound and the thinking mind retains its vigor, an old intelligence may have extraordinary breadth and depth of understanding. It's had more time to gather knowledge and more practice in comparison and judgment. No matter if the knowledge is intellectual or practical or emotional, if it concerns alpine ecosystems or the Buddha nature or how to reassure a frightened child: when you meet an old person with that kind of knowledge, if you have the sense of a bean sprout you know you're in a rare and irreproducible presence.

Same goes for old people who keep their skill at any craft or art they've worked at for all those years. Practice does make perfect. They *know how*, they know it all, and beauty flows effortlessly from what they do.

But all such existential enlargements brought by living long are under threat from the lessening of strength and stamina. However well compensated for by intelligent coping mechanisms, small or large breakdowns in one bit of the body or another begin to restrict activity, while the memory is dealing with overload and slippage. Existence in old age is progressively di-

minished by each of these losses and restrictions. It's no use saying it isn't so, because it is so.

It's no use making a fuss about it, or being afraid of it, either, because nobody can change it.

Yes, I know, we are, at the moment, in America, living longer. Ninety is the new seventy, etc. That's generally taken to be a good thing.

How good? In what respects?

I recommend studying the ovenbird's question long and seriously.

There are many answers to it. A lot can be made of a diminished thing, if you work at it. A lot of people (young and old) are working at it.

All I'm asking people who aren't yet really old is to think about the ovenbird's question too — and *try not to diminish old age itself.* Let age be age. Let your old relative or old friend be who they are. Denial serves nothing, no one, no purpose.

Please understand, I'm speaking for myself, for my own crabby old age. I may get told off for it by hordes of enraged octogenarians who *like* being told they're "spry" and "feisty." I don't begrudge the fairy tale to those who want to believe it — and if I live longer than I think I want to, maybe I'll even come to want to hear it: *You're not old! Nobody's old. We're all living happily ever after.*

Catching Up, Ha Ha

October 2014

IT'S BEEN TWO months since I blogged. Considering that I am on the eve of my eighty-fifth birthday, and that anyone over seventy-five who isn't continuously and conspicuously active is liable to be considered dead, I thought I should make some signs of life. Wave from the grave, as it were. Hello, out there! How are things in the Land of Youth? Here in the Land of Age they are rather weird.

The weirdness includes being called a liar by Hugh Woolly, the famous self-publisher of *How,* because I was rude to amazondotcom, the famous philanthropic organization dedicated to supporting publishers, encouraging writers, and greasing the skids of the American Dream. Various other weirdnesses have arisen in my life as a writer, some quite enjoyable. But the important and dominant weirdness of life this autumn consists of not having a car—a condition that to a lot of people is the American Nightmare.

We do have our nice Subaru, but we can't drive it. I never could. I learned to drive in 1947 but didn't get a license, for which I and all who know me are grateful. I'm one of those pedestri-

ans who start to cross the street, scuttle back to the curb for no reason, then suddenly leap out in front of your car just as you get into the intersection. I am the cause of several near accidents and a great deal of terrible swearing. It's awful to think what I might have done armed with an automobile. In any case, I don't drive. And since August, sciatic pain from stenosis keeps Charles from driving, and from walking much at all. I can walk (I have the same thing he has, fortunately much less severely), but after a few blocks I go lame on the left hind. We're ten steep blocks from our co-op market. So we've lost the liberty our legs or the car gave us to pop out and get what we needed when we needed it.

It's a wonderful freedom, much missed. I've had to go back to the routine of my childhood, when we did the shopping once a week. No running down to see what looks fresh and good for dinner or to pick up a quart of milk—everything has to be planned ahead and written down. If you don't get the cat litter on Tuesday, well, you don't have any cat litter till next Tuesday, and the cat may have some questions for you.

There's no hardship about shopping this way; in fact I look forward to it, since my friend Moe takes me, and is a really good, intense shopper who notices bargains and things. But still it's tiresome always having to think about it instead of just doing it.

Just do it!—the motto for those who run twenty miles every morning in swoosh-covered shoes, the mantra of undelayed gratification. Yeah, well. Charles and I do better with *Sí, se puede.* Or, with Gallic philosophy, *On y arrive.*

As for doctors' appointments, one of the finest paradoxes of senility is that the oftener you have to go to the doctor, the harder it is to get there. And haircuts! Now I know how the world looks to those little dogs with the bangs all over their eyes. It looks hairy.

All in all, the main effect of being inordinately old and carless is that there's even less time to do things other than what has to be done than there was before. Keeping up with answering letters, and writing blog posts, and getting the books in the basement organized, and a whole slew of things like that all get put on the back burner—which may or may not be functioning, as we have had the stove since 1960.

But you know, they don't make stoves like that anymore.

THE ANNALS OF PARD

Choosing a Cat

January 2012

I HAVE NEVER chosen a cat before. I have been chosen by the cat, or by people who offered us a cat. Or a kitten was weeping up in a tree on Euclid Avenue and needed to be rescued and grew up into a fourteen-pound gray tiger tom who populated our neighborhood in Berkeley for blocks around with gray tiger kittens. Or pretty golden Mrs. Tabby, probably after an affair with her handsome golden brother, presented us with several golden kittens, and we kept Laurel and Hardy. Or when Willie died, we asked Dr. Morgan to let us know if anybody left a kitten at the veterinary door the way people do, and she said it wasn't likely because it was long past kitten season, but next morning there was a six-month-old in a tuxedo on her doorstep, and she called us up, and so Zorro came home with us for thirteen years.

After Zorro died, last spring, there had to be the emptiness.

Finally it began to be time that the house had a soul again (some Frenchman said that the cat is the soul of the house, and we agree). But no cat had chosen us or been offered to us or appeared weeping in a tree. So I asked my daughter if she'd come to the Humane Society with me and help me choose a cat.

A middle-aged, sedate, homebody cat, suitable for owners in their eighties. Male, for no reason but that the cats I have loved most dearly were males. Black, I hoped, as I like black cats and had read that they are the least popular choice for adoption.

But I wasn't particular about details. I was nervous about going. I dreaded it, in fact.

How can you *choose* a cat? And what about the ones I couldn't choose?

The Humane Society's Portland office is an amazing place. It is immense, and I saw only the lobby and the cat wing—rooms and rooms and rooms of cats. There's always somebody, staff and volunteers, at hand if you want them. Everything is organized with such simple efficiency that it all seems easygoing and friendly—low-stress. When you are one of the huge number of people coming daily to bring in or adopt animals, when you see the endless incoming and outgoing of animals and glimpse the tremendous, endless work involved in receiving and treating and keeping them, the achievement of that easygoing atmosphere seems almost incredible and totally admirable.

The human/animal interface is a very troubled one these days, and in one sense the Humane Society shows that trouble at its most acute. Yet in everything I saw there, I also saw the best of what human beings can do when they put their heart and mind to it.

Well, so we found our way into the cat wing and looked about a bit, and it turned out that at the moment there were very few middle-aged cats for adoption. The ones that were there mostly came from one place, which I'd read about recently in the news-

paper: a woman with ninety cats who was sure she loved them all and was looking after them and they were all fine and ... you know the story, a sad one. The Humane Society had taken about sixty of them. The nice aide whom we began to follow around told us that they weren't in as bad shape as most animals in those situations, and were fairly well socialized, but they weren't in very good shape either, and would need special care for quite a while to come. That sounded a bit beyond me.

Aside from them, most of the cats there were kittens. Kittening was very late this year, she said. Just like tomatoing, I thought.

In one room of six or eight kittens, Caroline noticed an agitated nylon play-tube which seemed to contain at least two active animals, one black and one white. Eventually one small cat emerged, very black-and-white and pleased with himself. Our guide told us he was older than most of them—a year old. So we asked to see him. We went to the interview room and she came in with the little fellow in the tuxedo.

He seemed very small for a year old: seven pounds, she said. His tail stood straight up in the air, and he purred most amazingly, and talked a good deal in a rather high voice, and often fell over in a playful/appeasement position. He was clearly, and naturally, anxious. He clung a little to the aide, till she left us alone with him. He wasn't really shy, didn't mind being picked up and handled and petted, though he wouldn't settle on a lap. His eyes were bright, his coat sleek and soft, the black tail stood straight up, and the black spot on his left hind leg was terminally cute.

The aide came back, and I said, "OK."

She and my daughter were both a little surprised. Maybe I was too.

"You don't want to look at any others?" she asked.

No, I didn't. Send him back, look at other cats, make a choice of one, maybe not him? I couldn't. Fate or the Lord of the Animals or whatever had presented me with a cat, again. OK.

His previous owner had conscientiously filled out the Humane Society questionnaire. Her answers were useful and heartbreaking. Reading between some of the lines, I learned that he lived his first year with his mother and one sibling in a household where there were children under three, children from three to nine, and children from nine through fourteen, but no men.

The reason why all three cats were given up for adoption was stark: "Could not afford to keep."

He had been only four days at the Humane Society. They had neutered him right away and he was recovering fast; he was in excellent health, had been well fed, well treated, a sociable, friendly, playful, cheerful little pet. I do not like to think of the tears in that family.

He has been with us a month today. As his first owner warned, he is somewhat shy of men. But not very. And not afraid of children, though sensibly watchful. We lived thirteen years with shy, wary Zorro, who feared many things—including my daughter Caroline, because once she stayed in our house with two big, unruly dogs, and for ten years he never forgave her. But this fellow is not timid. In fact, he is perhaps too fearless. He grew up as an inside-outside cat. Here, he won't go outside till the weather gets warm. But then he must. I can only hope he knows what to be afraid of out there.

Like many young cats, he goes wild as a buck once or twice

a day, flying about the room about three feet off the ground, knocking things off and over, getting into all kinds of trouble. Shouts of disapproval are ineffective, little swats on the butt are slightly effective, and he understands, and remembers, what No! and a preventing hand in front of his nose means. But I found to my distress that sometimes a threateningly raised hand will cause him to cringe and crouch like a beaten dog. I don't know what that comes from, but I can't stand it. So shout and swat and No! is all I can do.

Vonda sent me a whole bucket full of Super Balls, wonderful for solo soccer games and working off excess energy. He's good at all varieties of String Game. When he wins at String-on-a-Stick, he walks off with the string and the stick and likes to carry the whole thing downstairs, clatter rattle bump. He is quite good at Paws Beneath the Door, but hasn't yet got the point of Paws Between the Banisters — because there were no banisters in the house he grew up in. That was clear the first few days, when he tried to navigate our stairs, a landform entirely new to him. The learning process was extremely funny, and dangerous to us ancients, who are unsteady enough on stairs without a confused cat suddenly appearing belly up on the next stair down or darting madly crossways right in front of your foot. But he mastered all that, and now races up and down far ahead of us, barely touching the stairs at all, as to the manor born.

They warned us at the Humane Society that there was a feline cold going around, probably from the rescued cats, and he probably had it; there's nothing they can do about it, any more than a kindergarten can. So he brought it home, and was a very snuffly little body for two weeks. Not a totally bad start, since he wanted to cuddle and sleep a lot, and we could get to know one another quietly. I didn't worry much about him, because he

had no fever and never for a moment lost his appetite. He had to snort to breathe while he ate, but he ate, and ate . . . Kibbles. Oh! Kibbles! Oh joy! Oh gourmet delight, oh tuna and sushi and chicken liver and caviar all in one! I guess kibbles is all he ever had to eat. So kibbles is Food. And he loves Food. He just loves it. He certainly won't bother us with his finicky, demanding tastes. But it may take strong willpower (ours) to prevent globularity in this cat. We will try.

He is pretty, but his only unusual beauty is his eyes, and you have to look closely to realize it. Right around the large dark pupil they are green, and around that reddish yellow. I had seen that magical change in a semiprecious stone: he has eyes of chrysoberyl. Wikipedia tells us that chrysoberyl or alexandrite is a trichroic gem. It shows emerald green, red, or orange-yellow depending on the angle of the light.

While he had the cold and we were lying around together I tried out names. Alexander was too imperial, Chrysoberyl far too majestic. Pico was one that seemed to fit him, or Paco. But the one he kept looking around at when I said it was Pard. It started out as Gattopardo (the Leopard, Lampedusa's Prince Fabrizio). That was too long for anybody his size, and got cut down to Pardo, and then turned into Pard, as in *pardner*.

Hey, Little Pard. I hope you choose to stay around a while.

Chosen by a Cat

April 2012

IN THE FOUR months since I wrote about his arrival, Little Pard has grown up. He is now Not Large But Quite Solid Pard. He's what they call a cobby cat, not a leggy one. When he sits upright, the view from the rear is pleasingly and symmetrically globular, a shining black sphere, plus head and tail. But he isn't fat. Though not for want of trying. He still loves kibbles, oh kibbles, oh lovely kibbles! Crunch, crunch, crunch to the last crumb, then look up with instant, infinite pathos—I starve, I perish, I have not eaten for weeks . . . He would love to be Pardo el Lardo. We are heartless. One half cup of food a day, the vet said, and we have obeyed her. One quarter cup of kibbles at seven, another at five. And, well, yes, there is a sixth of a can of catfood with warm water on it for lunch, to make sure he gets plenty of water. But he often leaves that till five when the kibbles arrive, the One True Food. And then he cleans both bowls and goes into the living room and maybe flies around a little bit, but mostly just sits and digests in bliss.

He is a vivid little creature. Youth is so dramatic! His tuxedo is utterly black and utterly white. He is utterly sweet and utterly

nutty. Wild as a bronco, inert as a sloth. One moment he's airborne, the next fast asleep. He is unpredictable, yet keeps strict routines—every morning he rushes over to greet Charles coming downstairs, falls over on the hall rug, and waves his paws in a posture of adoration. He still won't sit on a lap, though. I don't know if he ever will. He just doesn't accept the lap hypothesis.

Getting waked up by twenty minutes of strong, steady purring is very nice, plus the nose that investigates the neck, the paw that pats the hair . . . the increasing intensity of purr, the commencement of pouncing . . . By then it's quite easy to get up. Then he rushes into the bathroom ahead of me and flies around, mostly about waist level, getting into things; and he plays with the water I run for him in the bathtub and then leaps out to make wet flower paw prints here and there, or if I dribble him water in the washbasin he closes the stopper, thus creating a water hole where savage panthers may crouch in wait for dik-diks and gazelles, or possibly beetles. Then we go downstairs—one flying, the other not.

Closing the drain is typical. He's clever at opening cabinets too, because he likes getting into things, anything that can be got into—cabinets, drawers, boxes, bags, sacks, a quilt in progress, a sleeve. He is ingenious, adventurous, and determined. We call him the good cat with bad paws. The paws get him into trouble and cause loud shouting and scoldings and seizures and removals, which the good cat endures with patient good humor— "What are they carrying on about? I didn't knock that over. A paw did."

There used to be a lot of small delicate things on shelves around the house. There aren't now.

Charles bought him a little red harness. He is incredibly patient about having it put on—we thought it would be Charles

the Bloody-Handed for weeks, but no. He even purrs, somewhat plaintively, during the harnessing. Then the bungee leash is attached, and they go out and down the back steps into the garden for Pard's Walk. It went quite well twice, then a man running by outside the fence slapping his feet down galumph galumph scared Pard, and he wanted to go back inside at once, and is only beginning to get unscared of all the weirdnesses out there.

I think when it stops raining and we can sit outdoors with him it will be OK. He needs open space to fly around in, that's for sure. But then of course we fear he may get too bold in his enthusiasm and ignorance and wander into the wild backyards and thickets down the hill or chase a bird out into the street, and so get lost or meet the Enemy. The Enemy comes in so many forms to cats. They are small animals, predators yet very vulnerable, and Pard has neither street smarts nor wilderness wisdom. But he's bright. He deserves what freedom we can give him. Once it stops raining.

Meanwhile, he usually spends a good part of the day with me in my study, sleeping on the printer, about a foot from my right elbow. He fixated on me to start with and still tends to follow me up and down stairs and keep nearby, though he's gaining more independence, which is good—if I wanted to be the center of the universe I'd have a dog. My guess is that for the first year of his life, in a small and crowded household, he was never alone; so he needs time to get used to solitude, as well as to silence, boredom, never getting pursued or squashed by a passionate baby, etc.

Not wanting to be the center of the universe doesn't mean I don't love having a cat nearby. It seems we got his name right: he's a pardner, a true companion. I really like it when he sleeps at the top of my head on the pillow like a sort of fur nightcap. The

only trouble with his sleeping on the printer is that it's six inches from my Time Machine, which when it's saving stuff makes a weird, tiny, humming-clicking noise exactly like beetles. Pard knows that there are beetles in that box. Nothing I can say will change his mind. There are beetles in that box, and one day he will get his paw into it and get the beetles out and eat them.

Part Two

THE LIT BIZ

Would You Please Fucking Stop?

March 2011

I KEEP READING books and seeing movies where nobody can fucking say anything except *fuck*, unless they say *shit*. I mean they don't seem to have any adjective to describe fucking except *fucking* even when they're fucking *fucking*. And *shit* is what they say when they're fucked. When shit happens, they say *shit*, or *oh shit*, or *oh shit we're fucked*. The imagination involved is staggering. I mean, literally.

There was one novel I read where the novelist didn't only make all the fucking characters say *fuck* and *shit* all the time but she got into the fucking act *herself*, for shit sake. So it was full of deeply moving shit like "The sunset was just too fucking beautiful to fucking believe."

I guess what's happened is that what used to be a shockword has become a noise that's supposed to intensify the emotion in what you're saying. Or maybe it occurs just to bridge the gap between words, so that actual words become the shit that happens in between saying *fucking*?

Swearwords and shockwords used to mostly come out of religion. *Damn, damn it, hell, God, God-damned, God damn it to hell,*

Jesus, Christ, Jesus Christ, Jesus Christ Almighty, etc. etc. A few of them appeared, rarely, in nineteenth-century novels, usually as —— or more bravely as *By G—!* or *d—n!* (Archaic or dialect oaths such as *swounds, egad, gorblimey* were printed out in full.) With the twentieth century the religious-blasphemy oaths began to creep, and then swarm, into print. Censorship of words perceived as "sexually explicit" was active far longer. Lewis Gannett, the book reviewer for the old *New York Herald Tribune,* had a top-secret list of words the publisher had had to eliminate from *The Grapes of Wrath* before they could print it; after dinner one night Lewis read the list out loud to his family and mine with great relish. It couldn't have shocked me much, because I recall only a boring litany of boring words, mostly spoken by the Joads no doubt, on the general shock level of *titty.*

I remember my brothers coming home on leave in the Second World War and *never once swearing* in front of us homebodies: a remarkable achievement. Only later, when I was helping my brother Karl clean out the spring, in which a dead skunk had languished all winter, did I learn my first real cusswords, seven or eight of them in one magnificent, unforgettable lesson. Soldiers and sailors have always cursed—what else can they do? But Norman Mailer in *The Naked and the Dead* was forced to use the euphemistic invention *fugging,* giving Dorothy Parker the chance, which naturally she didn't miss, of cooing at him, "Oh, are you the young man who doesn't know how to spell *fuck?*"

And then came the sixties, when a whole lot of people started saying *shit,* even if they hadn't had lessons from their brother. And before long all the *shits* and *fucks* were bounding forth in print. And finally we began to hear them from the lips of the stars of Hollywood. So now the only place to get away from them is movies before 1990 or books before 1970 or way, way out

in the wilderness. But make sure there aren't any hunters out in the wilderness about to come up to your bleeding body and say, Aw, shit, man, I thought you was a fucking moose.

I remember when swearing, though tame by modern standards, was quite varied and often highly characteristic. There were people who swore as an art form—performing a dazzling juncture of the inordinate and the unexpected. It seems weird to me that only two words are now used as cusswords, and by many people used so constantly that they can't talk or even write without them.

Of our two swearwords, one has to do with elimination, the other (apparently) with sex. Both are sanctioned domains, areas like religion where there are rigid limits and things may be absolutely off-limits except at certain specific times or places.

So little kids shout *caca* and *doo-doo,* and big ones shout *shit.* Put the feces where they don't belong!

This principle, getting it out of place, off-limits, the basic principle of swearing, I understand and approve. And though I really would like to stop saying *Oh shit* when annoyed, having got on fine without it till I was thirty-five or so, I'm not yet having much success in regressing to *Oh hell* or *Damn it.* There is something about the *shh* beginning, and the explosive *t!* ending, and that quick little *ih* sound in between . . .

But *fuck* and *fucking?* I don't know. Oh, they sound good as curses too. It's really hard to make the word *fuck* sound pleasant or kindly. But what is it saying?

I don't think there are meaningless swearwords; they wouldn't work if they were meaningless. Does *fuck* have to do with sex primarily? Or sex as male aggression? Or just aggression?

Until maybe twenty-five or thirty years ago, as far as I know,

fucking only meant one kind of sex: what the man does to the woman, with or without consent. Now both men and women use it to mean coitus, and it's become (as it were) ungendered, so that a woman can talk about fucking her boyfriend. So the strong connotations of penetration and of rape should have fallen away from it. But they haven't. Not to my ear, anyhow. *Fuck* is an aggressive word, a domineering word. When the guy in the Porsche shouts *Fuck you, asshole!* he isn't inviting you to an evening at his flat. When people say *Oh shit, we're fucked!* they don't mean they're having a consensual good time. The word has huge overtones of dominance, of abuse, of contempt, of hatred.

So God is dead, at least as a swearword, but hate and feces keep going strong. *Le roi est mort, vive le fucking roi.*

Readers' Questions

I RECENTLY GOT a letter from a reader who, after saying he liked my books, said he was going to ask what might seem a stupid question—one I need not answer, though he really longed to know the answer to it. It concerned the wizard Ged's use-name Sparrowhawk. He asked, Is this the New World sparrowhawk, *Falco sparverius*, or one of the Old World kestrels, also *Falco*, or their sparrowhawks, which are not *Falco* but *Accipiter*?

(Warning: You can get into something of a tangle with these birds. Many people use the words *sparrowhawk* and *kestrel* interchangeably, but kestrels, Eurasian or American, are all falcons, while not all sparrowhawks are kestrels, or vice versa. You see what I mean? I am only sorry we lost the beautiful British name windhover. But we have G. M. Hopkins's poem.)

I immediately answered the letter as best I could. I said it seems to me it can't be any of the above, because it's not an Earth bird but an Earthsea bird, and Linnaeus did not go there with his can of names. But the bird I saw in my imagination when I was writing the book was definitely like our splendid little American *sparverius*, so maybe we could call it *Falco parvulus terramarinus*.

(I didn't think of *parvulus* [small] when I wrote the letter, but it should be there. A sparrowhawk is a quite small falcon. Ged was a scrappy boy, but short.)

After I'd answered the letter, I thought about how promptly and with what pleasure I'd done so. And I looked at the never-decreasing stack of letters waiting to be answered and thought how much I wanted to put off answering them, because so many of them would be so difficult, some so impossible . . . Yet I very much wanted to answer them, because they were written by people who liked or at least were responding to my work, had questions about it, and took the trouble to tell me so, and thus deserve the trouble—and sometimes the pleasure—of an answer.

What makes so many letters-to-the-author hard to answer? What have the difficult ones in common? I have been thinking about it for some days. So far, I've come up with this:

They ask large, general questions, sometimes stemming from some branch of learning the writers know way, way more about than I do, such as philosophy or metaphysics or information theory.

Or they ask large, general questions about how Taoism or feminism or Jungian psychology or information theory has influenced me—questions answerable in some cases only with a long PhD thesis, in others only with "Not much."

Or else they ask large, general questions based on large, general misconceptions about how writers work—such as, Where do you get your ideas from? What is the message of your book? Why did you write this book? Why do you write?

This last question (which is in fact highly metaphysical) is often asked by young readers. Some writers, even ones who don't actually write for a living, answer it "For money," which certainly stops all further discussion, being the deadest of dead ends. My

honest answer for it is "Because I like to," but that's seldom what the questioner wants to hear, or what the teacher wants to find in the book review or the term paper. They want something *meaningful.*

Meaning — this is perhaps the common note, the bane I am seeking. What is the Meaning of this book, this event in the book, this story . . . ? Tell me what it Means.

But that's not my job, honey. That's your job.

I know, at least in part, what my story means to me. It may well mean something quite different to you. And what it meant to me when I wrote it in 1970 may be not at all what it meant to me in 1990 or means to me in 2011. What it meant to anybody in 1995 may be quite different from what it will mean in 2022. What it means in Oregon may be incomprehensible in Istanbul, yet in Istanbul it may have a meaning I could never have intended . . .

Meaning in art isn't the same as meaning in science. The meaning of the second law of thermodynamics, so long as the words are understood, isn't changed by who reads it, or when, or where. The meaning of *Huckleberry Finn* is.

Writing is a risky bidness. No guarantees. You have to take the chance. I'm happy to take it. I love taking it. So my stuff gets misread, misunderstood, misinterpreted — so what? If it's the real stuff, it will survive almost any abuse other than being ignored, disappeared, not read.

"What it means," to you, is what it means to you. If you have trouble deciding what, if anything, it means to you, I can see why you might want to ask me, but please don't. Read reviewers, critics, bloggers, and scholars. They all write about what books mean to them, trying to explain a book, to achieve a valid common understanding of it useful to other readers. That's their job, and some of them do it wonderfully well.

It's a job I do as a reviewer, and I enjoy it. But my job as a fiction writer is to write fiction, not to review it. Art isn't explanation. Art is what an artist does, not what an artist explains. (Or so it seems to me, which is why I have a problem with the kind of modern museum art that involves reading what the artist says about a work in order to find out why one should look at it or "how to experience" it.)

I see a potter's job as making a good pot, not as talking about how and where and why she made it and what she thinks it's for and what other pots influenced it and what the pot means or how you should experience the pot. She can do that if she wants to, of course, but should she be expected to? Why? I don't expect her to, I don't even want her to. All I expect of a good potter is to go and make another good pot.

A question such as the one about sparrowhawks — not large, not general, not metaphysical, and not personal — a question of detail, of fact (in the case of fiction, imaginary fact) — a limited, specific question about a particular work — is one most artists are willing to try to answer. And questions about technique, if limited and precise, can be intriguing for the artist to consider ("Why did you use a mercury glaze?" or "Why do you/don't you write in the present tense?" for instance.)

Large, general questions about meaning, etc., can only be answered with generalities, which make me uncomfortable, because it is so hard to be honest when you generalize. If you skip over all the details, how can you tell if you're being honest or not?

But any question, if it is limited, specific, and precise, can be answered honestly — if only with "I honestly don't know, I never thought about it, now I have to think about it, thank you for asking!" I am grateful for questions like that. They keep me thinking.

Now, back to Hopkins and "The Windhover" —

I caught this morning morning's minion, king-
 dom of daylight's dauphin, dapple-dawn-drawn Falcon, in his riding
 Of the rolling level underneath him steady air, and striding
High there . . .

Ah, we could explain that, and talk about what it means, and why and how it does what it does, forever. And we will, I hope. But the poet, like the falcon, leaves that to us.

Kids' Letters

December 2013

PEOPLE SOMETIMES LOOK surprised when I say that I love to get fan letters from children. I'm surprised that they're surprised.

I get some very lovable letters from kids under ten who write me on their own, mostly with a little parental input. They often describe themselves as "Your Hugest Fan," which makes me imagine them as towering amiably over the Empire State Building. But most of the letters come from school classes that read the Catwings books. I try to answer these letters at least by thanking every child by name. I can't usually do much more than that.

Some are problematic: the teacher has told the kids to "write an author," making the assignment a requirement without regard for the students' feelings or capabilities—or mine. One desperate ten-year-old forced to write the author told me: "I have read the cover. it is prety good." What am I to say to him? His teacher put both him and me on the spot and left us there. Not fair.

Frequently teachers tell the students to tell the author what their favorite part of the book is and to ask a question. The favorite part is fine, the kid can always fake it; but asking a question is pointless unless the student really has one. It's also inconsider-

ate, raising the impossible expectation that a working author can write back with answers to twenty-five or thirty different questions, even if most of them are variations on two or three standard themes.

When teachers let the kids write whatever they want, if they want to write anything, it works. The questions are real, though some of them would stump the Sphinx. "Why do the catwings have wings?" "Why did you ever write books?" "I want to know how you make some of the words on the cover slanted." "My cat Boo is nine. I am ten. How old is your cat? Is it fair to catch mice?" And there are interesting criticisms. Kids are forthright, both positively and negatively; their comments tell me what interests and what disturbs them. "Did James ever get better from the Owl?" "I hate Mrs Jane Tabby she made her kitens go away from hom."

The class mailings I enjoy most are those where the teacher has encouraged the kids to draw their own pictures of scenes in the book, or to write sequels and continuations of the adventures of the Catwings.

"Catwings 5" and "Catwings 6" on ursulakleguin.com, posted quite a while back, are examples of one approach to this: the teacher has guided/collaborated with the students in making up the story, and has chosen the pictures to illustrate it. This is an admirable exercise in teamwork on an artistic project, and the result is charming. Adult control, however, inevitably tames the wild unpredictability of stories and pictures that come straight from each child's imagination. Such illustrations, stories, and booklets give me almost unalloyed delight.

The occasional alloy is in the now inevitable stories that imitate electronic games, a more alarming instance of adult control. In these, the Catwings go through "a portal" into the middle

of an incoherent adventure involving battles and the slaughter of enemies, monsters, etc., by the million. Evidently this is the only story the child knows. It's scary to see a mind trapped in an endless repetition of violent acts without meaning or resolution, only escalation to keep the stimulus going. So far this kind of thing has come only from boys, which may be, in its way, a hopeful sign. I remember hearing my next older brother in 1937 making up and acting out his own adventure stories in his room — shouts of defiance, muffled thuds, cries of "Get him! Get him!" and machine-gun fire. My brother came through all this mayhem as a quite unviolent adult. But the games of instantly rewarded destruction, in which the characters and action are ready-made "action figures" and the only goal is "winning," are designed to be addictive, and therefore may be hard to outgrow or replace. Compelled into an endless, meaningless feedback loop, the imagination is starved and sterilized.

As for the joy I get from the stories and booklets, a large part of it is in seeing that so many kids are perfectly willing to write a book (the book may be about fifty words long). They are confident about doing it and about illustrating it. They take obvious pleasure in giving it chapters, and a table of contents, and a cover, and a dedication. And at the end, they all write "The End" with a proud flourish. They should be proud. Their teacher is proud of them. I am proud of them. I hope their family is proud of them. To have written a book is a very cool thing, when you are six or eight or ten years old. It leads to other cool things, such as fearless reading. Why would anybody who's written a book be afraid of reading one?

As an experienced connoisseur, I can say the best letters and books by kids are entirely handmade. A computer may make writing easier, but that's not always an advantage: ease induces

haste and glibness. From the visual point of view, the printout, with all idiosyncratic characters blanded into a standard font, is drably neat, while the artisanal script is full of vitality. Computer spell-checking takes all the flavor out of the nonprescriptive, creative spelling that can give great delight to a reader. In a printout, nobody tells me what their favrit pert of the book is, or their favroit prt, or faevit palrt, or favf pont. In a printout, nobody asks me Wi did you disid to writ cat wigs? And there are no splendid final salutations, such as "Sensrle," which had me stumped, until "San serly" and "Sihnserly" gave me the clue. Or "Yours trully," also spelled "chrule." Or, frequently, echoing young Jane Austen, "Your freind." Or the occasional totally mysterious farewells— "mth frum Derik," "Fsrwey, Anna."

Frswey, brave teachers, brave children! (And thank you for the quotations!)

mth frum Ursula.

Having My Cake

April 2012

THE INABILITY TO understand proverbs is a symptom of
something—is it schizophrenia? Or paranoia? Anyhow, some-
thing very bad. When I heard that, many years ago, it worried
me. Everything I ever heard about a symptom worries me. Do I
have it? Yes! Yes, I do! Oh God!

And I had proof of my paranoia (or schizophrenia). There
was a very common proverb that I knew I'd never understood.

YOU CAN'T HAVE YOUR CAKE
AND EAT IT TOO.

My personal logic said, How can you eat a cake you don't have?

And since I couldn't argue with that, I silently stuck to it,
which left me in a dilemma: either the saying didn't make sense
(so why did intelligent people say it?) or I was schizophrenic (or
paranoid).

Years passed, during which now and then I puzzled over my
problem with the proverb. And slowly, slowly it dawned on me
that the word *have* has several meanings or shades of meaning,

the principal one being "own" or "possess," but one of the less common connotations is "hold on to," "keep."

YOU CAN'T KEEP YOUR CAKE AND EAT IT TOO.

Oh!

I get it!

It's a good proverb!

And I am not a paranoid schizophrenic!

But it seemed odd that I hadn't arrived sooner at the "keep" meaning of *have*. I puzzled over that for a while too, and finally came up with this:

For one thing, it seems to me that the verbs are in the wrong order. You have to have your cake before you eat it, after all. I might have understood the saying if it was "You can't eat your cake and have it too."

And then, another kind of confusion, having to do with *have*. In the West Coast dialect of English I grew up with, "I had cake at the party" is how we said, "I ate cake at the party." So "You can't have your cake and eat it too" was trying to tell me that I couldn't eat my cake and eat it too . . .

And hearing it that way as a kid, I thought, Hunh? but didn't say anything, because there is no way, no possible way, a kid can ask about everything grownups say that the kid thinks Hunh? about. So I just tried to figure it out. And once I got stuck with the illogic of the cake you have being the cake you can't eat, the possibility never occurred to me that it was all about hoarding vs. gobbling, or the necessity of choice when there is no middle way.

I expect you've had quite enough cake by now. I'm sorry.

But see, this is the kind of thing I think about a lot.

Nouns (*cake*), verbs (*have*), words, and the uses and misuses of words, and the meanings of words, and how the words and their meanings change with time and with place, and the derivations of words from older words or other languages—words fascinate me the way box elder beetles fascinate my friend Pard. Pard, at this point, is not allowed outside, so he has to hunt indoors. Indoors we have, at this point, no mice. But we have beetles. Oh yes Lord, we have beetles. And if Pard hears, smells, or sees a beetle, that beetle instantly occupies his universe. He will stop at nothing—he will root in wastebaskets, overturn and destroy small fragile objects, push large heavy dictionaries aside, leap wildly in the air or up the wall, stare unmoving for ten minutes at the unattainable light fixture in which a beetle is visible as a tiny moving silhouette . . . And when he gets the beetle, and he always does, he knows that you can't have your beetle and eat it too. So he eats it. Instantly.

I know, though I don't really like knowing it, that not many people share this particular fascination or obsession. With words, I mean, not beetles. Though I want to point out that Charles Darwin was almost as deeply fascinated by beetles as Pard is, though with a somewhat different goal. Darwin even put one in his mouth once, in a doomed attempt to keep it by eating it. It didn't work.* Anyhow, many people enjoy reading about the meaning and history of picturesque words and phrases, but not many enjoy brooding for years over a shade of significance of the verb *to have* in a banal saying.

* From Darwin's autobiography: "I will give proof of my zeal: one day, on tearing off some old bark, I saw two rare beetles, and seized one in each hand; then I saw a third and new kind, which I could not bear to lose, so that I popped the one which I held in my right hand into my mouth. Alas! It ejected some intensely acrid fluid, which burnt my tongue so that I was forced to spit the beetle out, which was lost, as was the third one."

Even among writers, not all seem to share my enjoyment of pursuing a word or a usage through the dictionaries and the wastebaskets. If I start doing it aloud in public, some of them look at me with horror or compassion, or try to go quietly away. For that reason, I'm not even certain that it has anything to do with my being a writer.

But I think it does. Not with being a writer per se, but with *my* being a writer, my way of being a writer. When asked to talk about what I do, I've often compared writing with handicrafts—weaving, pot-making, woodworking. I see my fascination with the word as very like, say, the fascination with wood common to carvers, carpenters, cabinetmakers—people who find a fine piece of old chestnut with delight, and study it, and learn the grain of it, and handle it with sensuous pleasure, and consider what's been done with chestnut and what you can do with it, loving the wood itself, the mere material, the stuff of their craft.

Yet when I compare my craft with theirs, I feel slightly presumptuous. Woodworkers, potters, weavers engage with real materials, and the beauty of their work is profoundly and splendidly bodily. Writing is so immaterial, so mental an activity! In its origin, it's merely artful speech, and the spoken word is no more than breath. To write or otherwise record the word is to embody it, make it durable; and calligraphy and typesetting are material crafts that achieve great beauty. I appreciate them. But in fact they have little more to do with what I do than weaving or pot-making or woodworking does. It's grand to see one's poem beautifully printed, but the important thing to the poet, or anyhow to this poet, is merely to *see it printed*, however, wherever —so that readers can read it. So it can go from mind to mind.

I work in my mind. What I do is done in my mind. And what my hands do with it in writing it down is not the same as what

the hands of the weaver do with the yarn, or the potter's hands with the clay, or the cabinetmaker's with the wood. If what I do, what I make, is beautiful, it isn't a physical beauty. It's imaginary, it takes place in the mind—my mind, and my reader's.

You could say that I hear voices and believe the voices are real (which would mean I was schizophrenic, but the proverb test proves I'm not—I do, I do understand it, Doctor!). And that then by writing what I hear, I induce or compel readers to believe the voices are real too . . . That doesn't describe it well, though. It doesn't feel that way. I don't really know what it is I've done all my life, this wordworking.

But I know that to me words are things, almost immaterial but actual and real things, and that I like them.

I like their most material aspect: the sound of them, heard in the mind or spoken by the voice.

And right along with that, inseparably, I like the dances of meaning words do with one another, the endless changes and complexities of their interrelationships in sentence or text, by which imaginary worlds are built and shared. Writing engages me in both these aspects of words, in an inexhaustible playing, which is my lifework.

Words are my matter—my stuff. Words are my skein of yarn, my lump of wet clay, my block of uncarved wood. Words are my magic, antiproverbial cake. I eat it, and I still have it.

Papa H

I WAS THINKING about Homer, and it occurred to me that his two books are the two basic fantasy stories: the War and the Journey.

I'm sure this has occurred to others. That's the thing about Homer. People keep going to him and discovering new things, or old things, or things for the first time, or things all over again, and saying them. This has been going on for two or three millennia. That is an amazingly long time for anything to mean anything to anybody.

Anyhow, so *The Iliad* is the War (actually only a piece of it, close to but not including the end), and *The Odyssey* is the Journey (There and Back Again, as Bilbo put it).

I think Homer outwits most writers who have written on the War, by not taking sides.

The Trojan war is not and you cannot make it be the War of Good vs. Evil. It's just a war, a wasteful, useless, needless, stupid, protracted, cruel mess full of individual acts of courage, cowardice, nobility, betrayal, limb-hacking-off, and disembowelment.

Homer was a Greek and might have been partial to the Greek side, but he had a sense of justice or balance that seems characteristically Greek—maybe his people learned a good deal of it from him? His impartiality is far from dispassionate; the story is a torrent of passionate actions, generous, despicable, magnificent, trivial. But it is unprejudiced. It isn't Satan vs. Angels. It isn't Holy Warriors vs. Infidels. It isn't hobbits vs. orcs. It's just people vs. people.

Of course you can *take* sides, and almost everybody does. I try not to, but it's no use, I just like the Trojans better than the Greeks. But Homer truly doesn't take sides, and so he permits the story to be tragic. By tragedy, mind and soul are grieved, enlarged, and exalted.

Whether war itself can rise to tragedy, can enlarge and exalt the soul, I leave to those who have been more immediately part of a war than I have. I think some believe that it can, and might say that the opportunity for heroism and tragedy justifies war. I don't know; all I know is what a *poem* about a war can do. In any case, war is something human beings do and show no signs of stopping doing, and so it may be less important to condemn it or to justify it than to be able to perceive it as tragic.

But once you take sides, you have lost that ability.

Is it our dominant religion that makes us want war to be between the good guys and the bad guys?

In the War of Good vs. Evil there can be divine or supernal justice but not human tragedy. It is by definition, technically, comic (as in *The Divine Comedy*): the good guys win. It has a happy ending. If the bad guys beat the good guys, unhappy ending, that's mere reversal, flip side of the same coin. The author is not impartial. Dystopia is not tragedy.

Milton, a Christian, had to take sides, and couldn't avoid comedy. He could approach tragedy only by making Evil, in the person of Lucifer, grand, heroic, and even sympathetic — which is faking it. He faked it very well.

Maybe it's not only Christian habits of thought but the difficulty we all have in growing up that makes us insist justice must favor the good.

After all, "Let the best man win" doesn't mean the good man will win. It means, "This will be a fair fight, no prejudice, no interference — so the best fighter will win it." If the treacherous bully fairly defeats the nice guy, the treacherous bully is declared champion. This is justice. But it's the kind of justice that children can't bear. They rage against it. *It's not fair!*

But if children never learn to bear it, they can't go on to learn that a victory or a defeat in battle, or in any competition other than a purely moral one (whatever that might be), has nothing to do with who is morally better.

Might does not make right — right?

Therefore right does not make might. Right?

But we want it to. "My strength is as the strength of ten because my heart is pure."

If we insist that in the real world the ultimate victor *must be* the good guy, we've sacrificed right to might. (That's what History does after most wars, when it applauds the victors for their superior virtue as well as their superior firepower.) If we falsify the terms of the competition, handicapping it, so that the good guys may lose the battle but always win the war, we've left the real world, we're in fantasy land — wishful thinking country.

Homer didn't do wishful thinking.

Homer's Achilles is a disobedient officer, a sulky, self-pitying

teenager who gets his nose out of joint and won't fight for his own side. A sign that Achilles might grow up someday, if given time, is his love for his friend Patroclus. But his big snit is over a girl he was given to rape but has to give back to his superior officer, which to me rather dims the love story. To me Achilles is not a good guy. But he is a good warrior, a great fighter—even better than the Trojan prime warrior, Hector. Hector is a good guy on any terms—kind husband, kind father, responsible on all counts—a mensch. But right does not make might. Achilles kills him.

The famous Helen plays a quite small part in *The Iliad.* Because I know that she'll come through the whole war with not a hair in her blond blow-dry out of place, I see her as opportunistic, immoral, emotionally about as deep as a cookie sheet. But if I believed that the good guys win, that the reward goes to the virtuous, I'd have to see her as an innocent beauty wronged by Fate and saved by the Greeks.

And people do see her that way. Homer lets us each make our own Helen; and so she is immortal.

I don't know if such nobility of mind (in the sense of the impartial "noble" gases) is possible to a modern writer of fantasy. Since we have worked so hard to separate History from Fiction, our fantasies are dire warnings, or mere nightmares, or else they are wish fulfillments.

I don't know any war story comparable to *The Iliad* except maybe the huge Indian epic the Mahabharata. Its five brother-heroes are certainly heroes, it's their story—but it's also the story of their enemies, also heroes, some of whom are really great guys—and it's all so immense and complicated and full of rights and wrongs and implications and gods who interfere even more directly than the Greek gods do—and then, after all, is the

end tragic or is it comic? The whole thing is like a giant cauldron of ever-replenished food you can dive your fork into and come out with whatever you need most to nourish you just then. But next time it may taste quite different.

And the taste of the Mahabharata as a whole is very, very different from that of *The Iliad,* above all because *The Iliad* is (unjust divine intervention aside) appallingly realistic and bloodthirstily callous about what goes on in a war. The Mahabharata's war is all dazzling fantasy, from the superhuman exploits to the superduper weapons. It's only in their spiritual suffering that the Indian heroes become suddenly, heartbreakingly, heart-changingly real.

As for the Journey:

The actual travel parts of *The Odyssey* are related or ancestral to all our fantasy tales of somebody setting off over sea or land, meeting marvels and horrors and temptations and adventures, possibly growing up along the way, and maybe coming back home at the end.

Jungians such as Joseph Campbell have generalized such journeys into a set of archetypal events and images. Though these generalities can be useful in criticism, I mistrust them as fatally reductive. "Ah, the Night Sea Voyage!" we cry, feeling that we have understood something important—but we've merely recognized it. Until we are actually on that voyage, we have understood nothing.

Odysseus's travels involve such a terrific set of adventures that I tend to forget how much of the book is actually about his wife and son—what goes on at home while he's traveling, how his son goes looking for him, and all the complications of his

homecoming. One of the things I love about *The Lord of the Rings* is Tolkien's understanding of the importance of what goes on back on the farm while the Hero is taking his Thousand Faces all round the world. But till you get back there with Frodo and the others, Tolkien never takes you back home. Homer does. All through the ten-year voyage, the reader is alternately Odysseus trying desperately to get to Penelope and Penelope desperately waiting for Odysseus—both the voyager and the goal—a tremendous piece of narrative time-and-place interweaving.

Homer and Tolkien are both also notably honest about the difficulty of being a far-traveled hero who comes home. Neither Odysseus nor Frodo is able to stay there long. I wish Homer had written something about how it was for King Menelaus when *he* got home, along with his wife Helen, whom he and the rest of the Greeks had fought for ten years to win back, while she, safe inside the walls of Troy, was prissing around with pretty Prince Paris (and then when he got bumped she married his brother). Apparently it never occurred to her to send Hubby #1, Menelaus, down there on the beach in the rain, an email, or even a text message. But then, Menelaus's family, for a generation or two, had been rather impressively unfortunate or, as we would say, dysfunctional.

Perhaps it isn't only fantasy that you can trace right back to Homer?

A Much-Needed Literary Award

January 2013

I FIRST LEARNED about the Sartre Prize from "NB," the reliably enjoyable last page of the London *Times Literary Supplement*, signed by J.C. The fame of the award, named for the writer who refused the Nobel in 1964, is or anyhow should be growing fast. As J.C. wrote in the November 23, 2012, issue, "So great is the status of the Jean-Paul Sartre Prize for Prize Refusal that writers all over Europe and America are turning down awards in the hope of being nominated for a Sartre." He adds with modest pride, "The Sartre Prize itself has never been refused."

Newly shortlisted for the Sartre Prize is Lawrence Ferlinghetti, who turned down a fifty-thousand-euro poetry award offered by the Hungarian division of PEN. The award is funded in part by the repressive Hungarian government. Ferlinghetti politely suggested that they use the prize money to set up a fund for "the publication of Hungarian authors whose writings support total freedom of speech."

I couldn't help thinking how cool it would have been if Mo Yan had used some of his Nobel Prize money to set up a fund for

the publication of Chinese authors whose writings support total freedom of speech. But this seems unlikely.

Sartre's reason for refusal was consistent with his refusal to join the Legion of Honor and other such organizations and characteristic of the gnarly and countersuggestible existentialist. He said, "It isn't the same thing if I sign Jean-Paul Sartre or if I sign Jean-Paul Sartre, Nobel Prize winner. A writer must refuse to let himself be turned into an institution." He was, of course, already an "institution," but he valued his personal autonomy. (How he reconciled that value with Maoism is not clear to me.) He didn't let institutions own him, but he did join uprisings, and was arrested for civil disobedience in the street demos supporting the strikes of May 1968. President de Gaulle quickly pardoned him, with the magnificently Gallic observation that "you don't arrest Voltaire."

I wish the Sartre Prize for Prize Refusal could have been called the Boris Pasternak Prize for one of my true heroes. But it wouldn't be appropriate, since Pasternak didn't exactly choose to refuse his 1958 Nobel. He had to. If he'd tried to go accept it, the Soviet government would have promptly, enthusiastically arrested him and sent him to eternal silence in a gulag in Siberia.

I refused a prize once. My reasons were mingier than Sartre's, though not entirely unrelated. It was in the coldest, insanest days of the Cold War, when even the little planet Esseff was politically divided against itself. My novelette *The Diary of the Rose* was awarded the Nebula Prize by the Science Fiction Writers of America. At about the same time, the same organization deprived the Polish novelist Stanislaw Lem of his honorary membership. There was a sizable contingent of Cold Warrior members who felt that a man who lived behind the iron curtain and was rude about American science fiction must be a Commie rat

who had no business in the SFWA. They invoked a technicality to deprive him of his membership and insisted on applying it. Lem was a difficult, arrogant, sometimes insufferable man, but a courageous one and a first-rate author, writing with more independence of mind than would seem possible in Poland under the Soviet regime. I was very angry at the injustice of the crass and petty insult offered him by the SFWA. I dropped my membership and, feeling it would be shameless to accept an award for a story about political intolerance from a group that had just displayed political intolerance, took my entry out of Nebula competition shortly before the winners were to be announced. The SFWA called me to plead with me not to withdraw it, since it had, in fact, won. I couldn't do that. So — with the perfect irony that awaits anybody who strikes a noble pose on high moral ground — my award went to the runner-up: Isaac Asimov, the old chieftain of the Cold Warriors.

What relates my small refusal to Sartre's big one is the sense that to accept an award from an institution is to be co-opted by, embodied as, the institution. Sartre refused this on general principle, while I acted in specific protest. But I do have sympathy for his distrust of allowing himself to be identified as something other than himself. He felt that the huge label "Success" that the Nobel sticks on an author's forehead would, as it were, hide his face. His becoming a "Nobelist" would adulterate his authority as Sartre.

Which is, of course, precisely what the commercial machinery of bestsellerdom and prizedom wants: the name as product. The guaranteed imprint of salable Success. Nobel Prize Winner So-and-so. Best-Selling Author Thus-and-such. Thirty Weeks on the *New York Times* Bestseller List Whozit. Jane D. Wonthepulitzer . . . John Q. MacArthurgenius . . .

It isn't what the people who established the awards want them to do or to mean, but it's how they're used. As a way to honor a writer, an award has genuine value, but the use of prizes as a marketing ploy by corporate capitalism, and sometimes as a political gimmick by the awarders, has compromised their value. And the more prestigious and valued the prize, the more compromised it is.

Still, I'm glad that José Saramago, a much tougher Marxist nut than Sartre, saw fit not to refuse the Nobel Prize. He knew nothing, not even Success, could compromise him, and no institution could turn him into itself. His face was his own face to the end. And despite the committee's many bizarre selections and omissions, the Nobel Prize for Literature retains considerable value, precisely because *it* is identified with such writers as Pasternak, or Szymborska, or Saramago. It bears at least a glimmer reflected from their faces.

All the same, I think the Sartre Prize for Prize Refusal should be recognized as a valuable and timely award, and what's more, one pretty safe to remain untainted by exploitation. I wish somebody really contemptible would award me a prize so I could be in the running for a Sartre.

TGAN and TGOW

September 2011

WHEN I WAS a young novelist, fairly often a reviewer would get fervent and declare that an obscure book such as *Call It Sleep,* or a hugely successful one such as *The Naked and the Dead,* was The Great American Novel. By writers the phrase was used half jokingly—What are you writing these days? Oh, you know, The Great American Novel. I don't think I've seen the phrase used at all for a couple of decades at least. Maybe we've given up on greatness, or anyhow on American greatness.

I began quite a while ago to resist declarations of literary greatness in the sense of singling out any one book as TGAN, or even making lists of the Great American Books. Partly because the supposed categories of excellence omitting all genre writing, and the awards and reading lists and canons routinely and unquestioningly favoring work by men in the eastern half of the United States, made no sense to me. But mostly because I didn't and don't think we have much idea of what's enduringly excellent until it's endured. Been around quite a long time. Five or six decades, to start with.

Of course the excellence of immediate, real impact, of an art that embodies the moment, is an excellent kind of excellence. Such a novel speaks to you *now,* this moment. It tells you what's going on when you need to know what's going on. It speaks to your age group or social group that nobody else can speak for, or it embodies whatever the current anguish is, or it shows a light at the end of the tunnel of the moment.

I think all the enduringly excellent books began, in fact, as immediately excellent, whether they were noticed at the time or not. Their special quality is to outlast the moment and carry immediacy, impact, meaning, undiminished or even increasing with time, to ages and people entirely different from those the novelist wrote for.

The Great American Novel . . . *Moby-Dick?* Not greatly noticed when published, but canonized in the twentieth century; no doubt A Great American Novel. And The Great (canonical) American Novelists—Hawthorne, James, Twain, Faulkner, etc., etc. . . . But two books keep getting left off these lists, two novels that to me are genuinely, immediately, and permanently excellent. Call them great if you like the word. Certainly they are American to the bone.

I won't talk about *Uncle Tom's Cabin,* much as I love and admire it, because I want to talk about the other one.

If somebody came up to me in a dark alley with a sharp knife and said, "Name The Great American Novel or die!" I would gasp forth, squeakily, *"The Grapes of Wrath!"*

I wouldn't have, a year ago.

I first read it when I was fifteen or sixteen. It was utterly and totally over the head of the little Berkeley High School girl (maybe "under her radar" is better, but we didn't know much about radar

in 1945 unless we were in the navy). I liked the chapter with the tortoise, early in the book. The end, the scene with Rose of Sharon and the starving man, fascinated and frightened and bewildered me so much that I couldn't either forget it or think about it.

Everything in the book was out of my experience, I didn't know these people, they didn't do things people I knew did. That I had been going to Berkeley High School with the children of the Joads simply did not occur to me. I was socially unaware as only a middle-class white kid in a middle-class white city can be.

I was dimly aware of changes. In the forties, the shipyards and other war employment brought a lot of people into Berkeley from the South and southern Midwest. What I mostly noticed was that, with no discussion or notice taken that I was aware of, the high school lunchroom had become segregated—self-segregated—white kids this side, black kids that side.

So OK, that's how it was now. When my brother Karl, three years older than me, was at BHS, the president of the student body had been a black kid—a Berkeley kid. That little, artificial, peaceable kingdom was gone forever. But I could keep living in it. On the white side of the lunchroom.

I lived in it with my best friend, Jean Ainsworth. Jean's mother, Beth, was John Steinbeck's sister. A widow with three children, Beth worked for Shell Oil and rented out rooms in their house, higher in the Berkeley Hills than ours, way up Euclid, with a huge view of the bay. The peaceable kingdom.

I got to know Uncle John a little when I was in college in the East and Jean was working in New York City, where he then lived. He was fond of his beautiful red-headed niece, though I don't know if he quite realized she was his equal in wit and heart.

Once I sat hidden with him and Jean under a huge bush at a huge wedding in Cleveland, Ohio, and drank champagne. Jean or I foraged forth for a new bottle now and then. It was Uncle John's idea.

At that wedding I had first heard, spoken in all seriousness, a now-classic phrase. People were talking about Jackie Robinson, and a man said, heavily, threateningly, "If this goes on, they'll be moving in next door."

It was after that that we hid under the bush with the champagne. "We need to get away from boring people and drink in peace," Uncle John said.

He did a bit too much of both those things, maybe, in his later life. He loved living high on the hog. He never went back to the austerity of his life when he was working on *The Grapes of Wrath*, and who can blame him, with fame and money pouring in on him? Maybe some books he might have written didn't get written and some he wrote could have been better.

I respect him for never jumping through all the hoops at Stanford, even if he kept going back and letting people like Wallace Stegner tell him what The Great American Novel ought to be. He could write rings around any of them, but they may have helped him learn his craft, or at least showed him how to act as if he had the kind of writerly confidence that life on a farm in Salinas didn't provide. Though it provided a great deal else.

Anyhow, when Jean and I were still in high school, 1945 or thereabouts, I read her famous uncle's famous novel and was awed, bored, scared, and uncomprehending.

And then sixty-some years later I thought, Hey, I really ought to reread some Steinbeck and see how it wears. So I went to Powell's and got *The Grapes of Wrath*.

When I got toward the end of the book, I stopped reading

it. I couldn't go on. I remembered just enough of that ending. And this time I was identified with all the people, I was lost in them, I had been living with Tom and Ma and Rose of Sharon day and night, through the great journey and the high hopes and the brief joys and the endless suffering. I loved them and I could not bear to think of what was coming. I didn't want to go through with it. I shut the book and ran away.

Next day I picked it up and finished it, in tears the whole time.

I don't cry much anymore when I read, only poetry, that brief rush when the hair stirs, the heart swells, the eyes fill. I can't remember when a novel broke my heart the way music can do, the way a tragic play does, the way this book did.

I'm not saying that a book that makes you cry is a great book. It would be a wonderful criterion if only it worked, but alas, it admits effective sentimentality, the knee-jerk/heartstring stimulus. For instance, a lot of us cry when reading of the death of an animal in a story—which in itself is interesting and significant, as if we give ourselves permission to weep the lesser tears—but that is something else and less. A book that makes me cry the way music can or tragedy can—deep tears, the tears that come of accepting as my own the grief there is in the world—must have something of greatness about it.

So now, if somebody asked me what book would tell them the most about what is good and what is bad in America, what is the most truly American book, what is the great American novel . . . a year ago I would have said—for all its faults—*Huckleberry Finn.* But now—for all its faults—I'd say *The Grapes of Wrath.*

I saw the movie of *The Grapes of Wrath,* and yes, it's a good movie, faithful to the elements of the book that it could handle, and yes, Henry Fonda was fine.

But a movie is something you see; a novel is something made out of language. And what's beautiful and powerful in this novel is its LANGUAGE, the art that not only shows us what the author saw but lets us share, as directly as emotion can be shared, his passionate grief, indignation, and love.

TGAN Again

November 2013

A QUESTION FROM New Bookends, "Where is the great American novel by a woman?," got an interesting answer from the Pakistani novelist Mohsin Hamid.*

> ... Bear with me as I advocate the death of the Great American Novel.
>
> The problem is in the phrase itself. "Great" and "Novel" are fine enough. But "the" is needlessly exclusionary, and "American" is unfortunately parochial. The whole, capitalized, seems to speak to a deep and abiding insecurity, perhaps a colonial legacy. How odd it would be to call Homer's "Iliad" or Rumi's "Masnavi" "the Great Eastern Mediterranean Poem."

I like this very much.

But there's something coy and coercive about the question itself that made me want to charge into the bullring, head down

* Quotations pulled from Mohsin Hamid's "Bookends" column, printed in the *New York Times Book Review* on October 15, 2013.

and horns forward.* I'd answer it with a question: Where is the great American novel by anybody? And I'd answer that: Who cares?

I think this is pretty much what Mr. Hamid says more politely, when he says that art

> is bigger than notions of black or white, male or female, American or non. Human beings don't necessarily exist inside of (or correspond to) the neat racial, gendered or national boxes into which we often unthinkingly place them. It's a mistake to ask literature to reinforce such structures. Literature tends to crack them. Literature is where we free ourselves.

Three cheers and Amen to that.

But I want to add this note: To me, the keystone of the phrase "the great American novel" is not the word *American* but the word *great*.

Greatness, in the sense of outstanding or unique accomplishment, is a cryptogendered word. In ordinary usage and common understanding, "a great American" means a great American man, "a great writer" means a great male writer. To regender the word, it must modify a feminine noun ("a great American woman," "a great woman writer"). To degender it, it must be used in a locution such as "great Americans/writers, both men and women . . ." Greatness in the abstract, in general, is still thought of as the province of men.

* In the 1920s, on a great Peruvian hacienda with a private bullring, my parents watched matadors-in-training fight cows. The full ritual was performed, except that injury to the animal was avoided, and it did not end in a kill. It was the best training, my parents were told: after *las vacas bravas*, bulls were easy. An angry bull goes for the red flag; an angry cow goes for the matador.

The writer who sets out to write the great American novel must see himself as a free citizen of that province, competing on equal ground with other writers, living and dead, for a glittering prize, a unique honor. His career is a contest, a battle, with victory over other men as its goal. (He is unlikely to think much about women as competitors.) Only in this view of the writer as a fully privileged male, a warrior, literature as a tournament, greatness as the defeat of others, can the idea of "the" great American novel exist.

That's a good deal to swallow, these days, for most writers over fourteen. I'll bet the whole notion of "the great American novel" is nothing like as common and meaningful an idea among authors as it is among readers, fans, PR people, reviewers, those who don't read but know authors by name as celebrities, and people who need something to blog about.

Now this may get me told off by women who value competitiveness and feel the problem with women is that they think they shouldn't or can't compete, but I'll say it all the same. It makes perfect sense to me that I've never heard a woman writer say she intended, or wanted, to write the great American novel.

Tell you true, I've never heard a woman writer say the phrase "the great American novel" without a sort of snort.

Whatever the virtues of competitiveness, women are still deeply trained by society to be cautious about laying claim to greatness greater than the greatness of men. As you know, Jim, a woman who competes successfully with men in a field men consider theirs by right risks being punished for it. Literature is a field a great many men consider theirs by right. Virginia Woolf committed successful competition in that field. She barely es-

caped the first and most effective punishment—omission from the literary canon after her death. Yet eighty or ninety years later charges of snobbery and invalidism are still used to discredit and diminish her. Marcel Proust's limitations and his neuroticism were at least as notable as hers. But that Proust needed not only a room of his own but a cork-lined one is taken as proof he was a genius. That Woolf heard the birds singing in Greek shows only that she was a sick woman.

So as long as men need to "be reflected at twice their natural size," a woman writer knows that open competition with them is dangerous. Even if she wants to write the, or a, great American novel, she's unlikely to announce (as male writers do from time to time) that she plans to or has written it. And if she feels she deserves a Pulitzer or Booker or Nobel, or anyhow wouldn't mind having one, she knows most literary awards are weighted so heavily in favor of men that the social efforts involved in most major awards, the networking and careful self-presentation, are a great expense for an unlikely return.

But risk avoidance isn't all there is to it. Because competition for primacy, for literary supremacy, doesn't seem as glamorously possible for women as it does for men, the whole idea of singular greatness—of there being one great anything—may not have the hold on a woman's imagination that it has on a man's. The knights in the lists have to believe the prize can be won and is worth winning. Those relegated to the preliminary jousts and the sidelines can see more clearly how arbitrary the judgment of championship is, and can question the value of the glittering prize.

Who wants "The" Great American Novel, anyhow? PR people. People who believe that bestsellers are better than other books because they sell better than other books and that the

prizewinning book is the best book because it won the prize. Tired teachers, timid teachers, lazy students who'd like one text to read instead of the many, many great and greatly complex books that make up literature.

Art is not a horse race. Literature is not the Olympics. The hell with The Great American Novel. We have all the great novels we need right now — and right now some man or woman is writing a new one we won't know we needed till we read it.

The Narrative Gift as a
Moral Conundrum

May 2012

THE NARRATIVE GIFT, is that what to call it? The storyteller's knack, as developed in writing.

Storytelling is clearly a gift, a talent, a specific ability. Some people just don't have it — they rush or drone, jumble the order of events, skip essentials, dwell on inessentials, and then muff the climax. Don't we all have a relative who we pray won't launch into a joke or a bit of family history because the history will bore us and the joke will bomb? But we may also have a relative who can take the stupidest, nothingest little event and make it into what copywriters call a gut-wrenchingly brilliant thriller and a laugh riot. Or, as Cousin Verne says, that Cousin Myra, she sure knows how to tell a story.

When Cousin Myra goes literary, you have a force to contend with.

But how important is that knack to writing fiction? How much of it, or what kind of it, is essential to excellence? And what is the connection of the narrative gift with literary quality?

❧

I'm talking about story, not about plot. E. M. Forster had a low opinion of story. He said story is "The queen died and then the king died," while plot is "The queen died and then the king died of grief." To him, story is just "this happened and then this happened and then this happened," a succession without connection; plot introduces connection or causality, therefore shape and form. Plot makes sense of story. I honor E. M. Forster, but I don't believe this. Children often tell "this happened and then this happened," and so do people naively recounting their dream or a movie, but in literature, story in Forster's sense doesn't exist. Not even the silliest "action" potboiler is a mere succession of unconnected events.

I have a high opinion of story. I see it as the essential trajectory of narrative: a coherent, onward movement, taking the reader from Here to There. Plot, to me, is variation or complication of the movement of story.

Story goes. Plot elaborates the going.

Plot hesitates, pauses, doubles back (Proust), forecasts, leaps, doubling or tripling simultaneous trajectories (Dickens), diagrams a geometry onto the story line (Hardy), makes the story Ariadne's string leading through a labyrinth (mysteries), turns the story into a cobweb, a waltz, a vast symphonic structure in time (the novel in general) . . .

There are supposed to be only so many plots (three, five, ten) in all fiction. I don't believe that either. Plot is manifold, inexhaustibly ingenious, endless in connections and causalities and complications. But through all the twists and turns and red herrings and illusions of plot, the trajectory of story is there, going forward. If it isn't going forward, the fiction founders.

I suppose plot without story is possible—perhaps one of those incredibly complex cerebral spy thrillers where you need

a GPS to get through the book at all. And story without plot occurs occasionally in literary fiction (Woolf's "The Mark on the Wall," perhaps)—oftener in literary nonfiction. A biography, for instance, can't really have a plot, unless the subject obligingly provided one by living it. But the great biographers make you feel that the story of the life they've told has an aesthetic completeness equal to that of plotted fiction. Lesser biographers and memoirists often invent a plot to foist onto their factual story— they don't trust it to work by itself, so they make it untrustworthy.

I believe a good story, plotted or plotless, rightly told, is satisfying as such and in itself. But here, with "rightly told," is my conundrum or mystery. Inept writing lames or cripples good narrative only if it's truly inept. An irresistibly readable story can be told in the most conventional, banal prose, if the writer has the gift.

I read a book last winter that does an absolutely smashing job of storytelling, a compulsive page-turner from page 1 on. The writing is competent at best, rising above banality only in some dialogue (the author's ear for the local working-class dialect is pitch-perfect). Several characters are vividly or sympathetically portrayed, but they're all stereotypes. The plot has big holes in it, though only one of them really damages credibility. The story line: an ambitious white girl in her early twenties persuades a group of black maids in Jackson, Mississippi, in 1964, to tell her their experiences with their white employers past and present, so that she can make a book of their stories and share them with the world by selling it to Harper and Row, and go to New York and be rich and famous. They do, and she does. And except for a

couple of uppity mean white women getting some egg on their face, nobody suffers for it.

All Archimedes wanted was a solid place to put the lever he was going to move the world with. Same with a story trajectory. You can't throw a shot put far if you're standing on a shaky two-inch-wide plank over a deep, dark river. You need a solid footing.

Or do you?

All this author had to stand on is a hokey, sentimental notion, and from it she threw this perfect pitch!

Seldom if ever have I seen the power of pure story over mind, emotion, and artistic integrity so clearly shown.

And I had to think about it, because a few months earlier, I'd read a book that brilliantly demonstrates a narrative gift in the service of clear thought, honest feeling, and passionate integrity. It tells an extremely complicated story extending over many decades and involving many people, from geneticists cloning cells in cloistered laboratories to families in the shack-houses of black farming communities. The story explains scientific concepts and arguments with great clarity while never for a moment losing its onward impetus. It handles the human beings it involves with human compassion and a steady, luminous ethical focus. The prose is of unobtrusive excellence. And if you can stop reading it, you're a better man than I am, Gunga Din. I couldn't stop even when I got to the notes—even when I got to the index. More! Go on! Oh please tell me more!

I see a huge difference in literary quality between these two hugely readable books, which certainly has to do with specific qualities of character—among them patience, honesty, risk-taking.

Kathryn Stockett, the white woman who wrote *The Help*, tells of a white girl persuading black women to tell her intimate details of the injustices and hardships of their lives as servants—a highly implausible undertaking in Mississippi in '64. When the white employers begin to suspect this tattling, only an equally implausible plot trick lets the black maids keep their jobs. Their sole motivation is knowing their stories will be printed; the mortal risk they would have run in bearing such witness, at that place in that year, is not seriously imagined, but merely exploited to create suspense. White Girl's motivation is a kind of high-minded ambition. Her risks all become rewards—she loses malevolent friends and a bigoted boyfriend and leaves Mississippi behind for a brilliant big-city career. The author's sympathy for the black women and knowledge of their everyday existence is evident, but, for me, it was made questionable by her assumption of a right to speak for people without earning that right, and killed dead by the wish-fulfilling improbability of her story.

Rebecca Skloot, the white woman who wrote *The Immortal Life of Henrietta Lacks*, spent years researching a vastly complex web of scientific research, thefts, discoveries, mistakes, deceits, cover-ups, exploitations, and reparations, while at the same time trying, with incredible patience and good will, to gain the trust of the people most directly affected by the one human life with which all that research and profit-making began—the family of Henrietta Lacks. These were people who had good reason to feel that they would be endangered or betrayed if they trusted any white person. It took her literally years to win their confidence. Evidently she showed them that she deserved it by her patient willingness to listen and learn, her rigorous honesty, and

her compassionate awareness of who and what was and is truly at risk.

"Of course her story is superior," says Mr. Gradgrind. "It's nonfiction—it's true. Fiction is mere hokum."

But oh, Mr. Gradgrind, so much nonfiction is awful hokum! How bad and mean my mommy was to me before I found happiness in buying a wonderful old castle in Nodonde and fixing it up as an exclusive gourmet B&B while bringing modern educational opportunities to the village children . . .

And contrarily, we can learn so much truth by reading novels, such as the novel in which you appear, Mr. Gradgrind.

No, that's not where the problem lies. The problem—my problem—is with the gift of story.

If one of the two books I've been talking about is slightly soiled fluff while the other is solid gold, how come I couldn't stop reading either of them?

It Doesn't Have to Be the Way It Is

June 2011

> The test of fairyland [is that] you cannot imagine two and one not making three but you can easily imagine trees not growing fruit; you can imagine them growing golden candlesticks or tigers hanging on by the tail.

THE QUOTATION, FROM G. K. Chesterton, is from an interesting article by Bernard Manzo in the *Times Literary Supplement* of June 10, 2011 (he didn't give the source in Chesterton's writings). It got me to thinking about how imaginative literature, from folktale to fantasy, operates, and to wondering about its relationship to science, though I'll only get to that at the very end of this piece.

The fantastic tale may suspend the laws of physics — carpets fly; cats fade into invisibility, leaving only a smile — and of probability — the youngest of three brothers always wins the bride; the infant in the box cast upon the waters survives unharmed — but it carries its revolt against reality no further. Mathematical order is unquestioned. Two and one make three, in Koschei's castle and Alice's Wonderland (especially in Wonderland). Euclid's

geometry—or possibly Riemann's—somebody's geometry, anyhow—governs the layout. Otherwise incoherence would invade and paralyze the narrative.

There lies the main difference between childish imaginings and imaginative literature. The child "telling a story" roams about among the imaginary and the half-understood without knowing the difference, content with the sound of language and the pure play of fantasy with no particular end, and that's the charm of it. But fantasies, whether folktales or sophisticated literature, are stories in the adult, demanding sense. They can ignore certain laws of physics but not of causality. They start *here* and go *there* (or back *here*), and though the mode of travel may be unusual, and *here* and *there* may be wildly exotic and unfamiliar places, yet they must have both a location on the map of that world and a relationship to the map of our world. If not, the hearer or reader of the tale will be set adrift in a sea of inconsequential inconsistencies, or, worse yet, left drowning in the shallow puddle of the author's wishful thinking.

It doesn't have to be the way it is. That is what fantasy says. It doesn't say, "Anything goes"—that's irresponsibility, when two and one make five, or forty-seven, or whuddevva, and the story doesn't "add up," as we say. Fantasy doesn't say, "Nothing is"— that's nihilism. And it doesn't say, "It ought to be *this* way"— that's utopianism, a different enterprise. Fantasy isn't meliorative. The happy ending, however enjoyable to the reader, applies to the characters only; this is fiction, not prediction and not prescription.

It doesn't have to be the way it is is a playful statement, made in the context of fiction, with no claim to "being real." Yet it is a subversive statement.

Subversion doesn't suit people who, feeling their adjust-

ment to life has been successful, want things to go on just as they are, or people who need support from authority assuring them that things are as they have to be. Fantasy not only asks "What if things didn't go on just as they do?" but demonstrates what they might be like if they went otherwise—thus gnawing at the very foundation of the belief that things have to be the way they are.

So here imagination and fundamentalism come into conflict.

A fully created imaginary world is a mental construct similar in many respects to a religious or other cosmology. This similarity, if noticed, can be deeply disturbing to the orthodox mind.

When a fundamental belief is threatened the response is likely to be angry or dismissive—either "Abomination!" or "Nonsense!" Fantasy gets the abomination treatment from religious fundamentalists, whose rigid reality-constructs shudder at contact with questioning, and the nonsense treatment from pragmatic fundamentalists, who want to restrict reality to the immediately perceptible and the immediately profitable. All fundamentalisms set strict limits to the uses of imagination, outside which the fundamentalist's imagination itself runs riot, fancying dreadful deserts where God and Reason and the capitalist way of life are lost, forests of the night where tigers hang from trees by the tail, lighting the way to madness with their bright burning.

Those who dismiss fantasy less fiercely, from a less absolutist stance, usually call it dreaming, or escapism.

Dream and fantastic literature are related only on a very deep, usually inaccessible level of the mind. Dream is free of intellectual control; its narratives are irrational and unstable, and its aesthetic value is mostly accidental. Fantastic literature, like all the verbal arts, must satisfy the intellectual as well as the aes-

thetic faculty. Fantasy, odd as it sounds to say so, is a perfectly rational undertaking.

As for the charge of escapism, what does *escape* mean? Escape from real life, responsibility, order, duty, piety, is what the charge implies. But nobody, except the most criminally irresponsible or pitifully incompetent, escapes to jail. The direction of escape is toward freedom. So what is "escapism" an accusation of?

"Why are things as they are? Must they be as they are? What might they be like if they were otherwise?" To ask these questions is to admit the contingency of reality, or at least to allow that our perception of reality may be incomplete, our interpretation of it arbitrary or mistaken.

I know that to philosophers what I'm saying is childishly naive, but my mind cannot or will not follow philosophical argument, so I must remain naive. To an ordinary mind not trained in philosophy, the question—do things have to be the way they are/the way they are here and now/the way I've been told they are?—may be an important one. To open a door that has been kept closed is an important act.

Upholders and defenders of a status quo, political, social, economic, religious, or literary, may denigrate or diabolize or dismiss imaginative literature, because it is—more than any other kind of writing subversive *by nature*. It has proved, over many centuries, a useful instrument of resistance to oppression.

Yet as Chesterton pointed out, fantasy stops short of nihilist violence, of destroying all the laws and burning all the boats. (Like Tolkien, Chesterton was an imaginative writer and a practicing Catholic, and thus perhaps particularly aware of tensions

and boundaries.) Two and one make three. Two of the brothers fail the quest, the third carries it through. Action is met with re-action. Fate, Luck, Necessity are as inexorable in Middle-earth as in Colonus or South Dakota. The fantasy tale begins *here* and ends *there* (or back *here*), where the subtle and ineluctable obliga-tions and responsibilities of narrative art have taken it. Down on the bedrock, things are as they have to be. It's only everywhere above the bedrock that nothing has to be the way it is.

There really is nothing to fear in fantasy unless you are afraid of the freedom of uncertainty. This is why it's hard for me to imagine that anyone who likes science can dislike fantasy. Both are based so profoundly on the admission of uncertainty, the welcoming acceptance of unanswered questions. Of course the scientist seeks to ask how things are the way they are, not to imagine how they might be otherwise. But are the two opera-tions opposed, or related? We can't question reality directly, only by questioning our conventions, our belief, our orthodoxy, our construction of reality. All Galileo said, all Darwin said, was, "It doesn't have to be the way we thought it was."

Utopiyin, Utopiyang

April 2015

THESE ARE SOME thoughts about utopia and dystopia.

The old, crude Good Places were compensatory visions of controlling what you couldn't control and having what you didn't have here and now—an orderly, peaceful heaven; a paradise of houris; pie in the sky. The way to them was clear, but drastic. You died.

Thomas More's secular and intellectual construct *Utopia* was still an expression of desire for something lacking here and now—rational human control of human life—but his Good Place was explicitly No Place. Only in the head. A blueprint without a building site.

Ever since, utopia has been located not in the afterlife but just off the map, across the ocean, over the mountains, in the future, on another planet, a livable yet unattainable elsewhere.

Every utopia since *Utopia* has also been, clearly or obscurely, actually or possibly, in the author's or in the readers' judgment, both a good place and a bad one. Every eutopia contains a dystopia, every dystopia contains a eutopia.

In the yang-yin symbol each half contains within it a portion

of the other, signifying their complete interdependence and continual intermutability. The figure is static, but each half contains the seed of transformation. The symbol represents not a stasis but a process.

It may be useful to think of utopia in terms of this long-lived Chinese symbol, particularly if one is willing to forgo the usual masculinist assumption that yang is superior to yin, and instead consider the interdependence and intermutability of the two as the essential feature of the symbol.

Yang is male, bright, dry, hard, active, penetrating. Yin is female, dark, wet, easy, receptive, containing. Yang is control, yin acceptance. They are great and equal powers; neither can exist alone, and each is always in process of becoming the other.

Both utopia and dystopia are often an enclave of maximum control surrounded by a wilderness—as in Butler's *Erewhon*, E. M. Forster's "The Machine Stops," and Yevgeny Zamyatin's *We*. Good citizens of utopia consider the wilderness dangerous, hostile, unlivable; to an adventurous or rebellious dystopian it represents change and freedom. In this I see examples of the intermutability of the yang and yin: the dark mysterious wilderness surrounding a bright, safe place, the Bad Places—which then become the Good Place, the bright, open future surrounding a dark, closed prison . . . Or vice versa.

In the last half century this pattern has been repeated perhaps to exhaustion, variations on the theme becoming more and more predictable, or merely arbitrary.

Notable exceptions to the pattern are Huxley's *Brave New World*, a eudystopia in which the wilderness has been reduced to an enclave so completely dominated by the intensely controlled

yang world-state that any hope of its offering freedom or change is illusory; and Orwell's 1984, a pure dystopia in which the yin element has been totally eliminated by the yang, appearing only in the receptive obedience of the controlled masses and as manipulated delusions of wilderness and freedom.

Yang, the dominator, always seeks to deny its dependence on yin. Huxley and Orwell uncompromisingly present the outcome of successful denial. Through psychological and political control, these dystopias have achieved a nondynamic stasis that allows no change. The balance is immovable: one side up, the other down. Everything is yang forever.

Where is the yin dystopia? Is it perhaps in post-holocaust stories and horror fiction with its shambling herds of zombies, the increasingly popular visions of social breakdown, total loss of control—chaos and old night?

Yang perceives yin only as negative, inferior, bad, and yang has always been given the last word. But there is no last word.

At present we seem only to write dystopias. Perhaps in order to be able to write a utopia we need to think yinly. I tried to write one in *Always Coming Home*. Did I succeed?

Is a yin utopia a contradiction in terms, since all the familiar utopias rely on control to make them work, and yin does not control? Yet it is a great power. How does it work?

I can only guess. My guess is that the kind of thinking we are, at last, beginning to do about how to change the goals of human domination and unlimited growth to those of human adaptability and long-term survival is a shift from yang to yin, and so involves acceptance of impermanence and imperfection, a patience with uncertainty and the makeshift, a friendship with water, darkness, and the earth.

THE ANNALS OF PARD

The Trouble

I'VE NEVER HAD a cat before who directly challenged me. I don't look for much obedience from a cat; the relationship isn't based on rank or a dominance hierarchy as with dogs, and cats have no guilt and very little shame. I expect a cat to steal food left out on the counter knowing perfectly well that he'll be swatted if caught. Greed, and possibly the joy of theft, overrides the slight fear. Stupid human me to leave food out on the counter. I expect a cat who has been scolded or swatted for getting up on the dining table to get up on the dining table and leave little footprints all over it, because he sees no reason to refrain from doing so when I'm not in the room. When found later, the evidence of the little footprints will have passed the statute of limitations. To make any sense to a cat, retaliation for wrongdoing must be immediate. The cat knows that as well as I do, which is why I expect him to do wrong while I'm not in the room, and don't expect him to do wrong while I am.

To do wrong under my very eyes strains our relationship. It demands scolding, swatting, shouting, flight, pursuit, commotion. It is a challenge, a deliberate invitation to trouble. And this

is where Pard is different from the many and various cats who have companioned me. They were all like me—they wanted to avoid trouble.

Pard wants to make it.

He isn't a troublesome cat. His hygiene is impeccable. He is gentle. He never steals food. (To be sure, this is only because he doesn't recognize anything but kibbled catfood as food. I can leave the pork cutlets on the counter while he's waiting hungrily for his quarter cup of dinner kibbles, and he won't even get up to sniff them. I could put a piece of bacon on top of his kibbles and he would eat them and leave it. I could lay a filet of sole down on him and he would shake it off with contempt and go away.)

He challenges me by doing what he's forbidden to do. And I guess there really aren't a lot of things he's forbidden, besides jumping up on the mantel and knocking off the kachinas.

He isn't allowed to get on the dining table, but there's nothing to do there but leave footprints. The mantel, which is a really big jump even for Pard, is the only unprotected display place left in the house for small ornamental things; all the others have found safe havens unreachable even by airborne cats. So jumping up onto the mantel has become his goal, his challenge.

But only if I am in the room.

He'll spend all day in the living room and never look at the fireplace until I come in. A while after we've both been there, Pard begins to glance at the mantelpiece. His eyes get rounder and blacker. He wanders carelessly about on a chair arm (allowed) or side table (allowed) near the fireplace. He stands up on his hind legs to sniff a lampshade or the top of the fire screen very thoroughly with enormous interest, always a little closer to the mantelpiece. Till, usually when I'm not looking but not quite not looking, he's airborne, and up on the mantel knocking

something off. Then scolding, shouting, flight, pursuit, etc.— Trouble! Mission accomplished.

Recently there is an added element: the squirt bottle. As soon as he looks at the mantel I pick up the squirt bottle. The first couple of times, when he made ready to jump onto the mantel and I squirted him, he was totally taken aback. He didn't even associate the squirt with the bottle. He does now. But it merely adds a new flavor, a new spice, to the Trouble. It doesn't keep him off the mantel.

I gave in a couple of days ago and moved all the little kachinas to a haven, leaving only the two big ones and some outstanding rocks. But this morning, while I was doing downward dog with my back turned, Pard jumped up onto the mantel and knocked off the lump of Tibetan turquoise, taking a chip out of it when it hit the hearth.

The ensuing Trouble was pretty intense, although I never could get anywhere near close enough to swat him. He knew I was mad. He has been terribly polite ever since, and inclined to fall over and wave his paws in an innocently endearing manner. He'll go on that way till we're all in the living room this evening and the need for Trouble arises in him again.

This little cat so deeply shaped by human expectation, the tamest cat I ever had, has a flame of absolute, willful wildness.

I'm sure some of it's the boredom factor—a young cat with old people, an indoors cat ... But Pard doesn't have to be an indoors cat. He chooses to.

The cat flap is opened for him all through daylight, at his request or at our suggestion. Sometimes he goes out onto the deck, looks down into the garden, birdwatches for a few minutes, and comes back. Or he may go out and turn right around and come back. Or he may say, Oh, no, thanks, it's very large out

there, and quite cold this time of year, so I think I'll stand here halfway out the cat flap for a while and then back back in. What he doesn't do is stay out. When the weather warms up and we're outside too, he will, but not enthusiastically. He'll go out and go down and eat some of the kind of grass that makes him throw up and come back indoors and throw it up on the rug. That isn't Trouble-making, it's just Cat-being.

There is no moral to this story, and no conclusion. Wish me luck with the squirt bottle.

Pard and the Time Machine

May 2014

PEOPLE WHO THINK of me as a Sci-Fi Writer will not be surprised to hear that there is a Time Machine in my study. So far it hasn't transported me among the Eloi and the Morlocks or back among the dinosaurs. Fine with me. I'll take the time I got, thanks. All my Time Machine does is save stuff from my computer and provide interest and occupation to my cat.

In Pard's first year with us he spent a lot of time on beetles, because we had a lot of them. The box elder beetle is now endemic in Portland, having shifted its allegiance from box elders, which we don't have, to big-leaf maples, which we have lots of. And so we have beetles, who live under the siding boards of the house and breed, and swarm, and creep and seep impossibly through nonexistent crevices of the window frames into the house, where they mass on sunlit windows and blunder about infuriatingly, getting under pillows and papers and feet, and into everything, including cups of tea and Charles's ears. Mostly they crawl, but they fly when alarmed. They are rather pretty little beetles, and harmless, but intolerable, because (like us) there are too many of them for their own good.

Pard used to see them as animated kibbles and enjoyed the chase, the pounce, the crunch. But evidently they weren't as tasty as Meow Mix or dental Greenies, and anyhow, enough beetles is enough. He now ignores them as steadfastly as we do, or try to.

But back then, when the Time Machine made its little clicky-whirry-insectlike internal noises, he was sure that it contained or concealed beetles, and spent a good deal of time trying to get inside it. It is 7.5 inches square and 1.5 inches high, white plastic, fortunately very tough white plastic, well and tightly sealed all round, and quite heavy for its size. All his efforts barely scratched the surface. As it continued to resist him, and his interest in beetles cooled, he stopped trying to open the Time Machine. He discovered that it offered other possibilities.

Its normal temperature is high, quite warm to the hand (and I think it gets hotter when performing its secret and mysterious connective operations in putative virtuality or the clouds of Unknowing or wherever it is it saves stuff).

My study, being half windows, is drafty and sometimes pretty cold in winter. As he came out of airborne youth and began to spend more time lying around near me in the study, Pard, being a cat, found the Warm Place.

He's there right now, although today, the last of April, my thermometer says it's 77 degrees and rising. He is sound asleep. About one fifth of him is right on top of the Time Machine. The rest of him, paws and so on, spills over to the desk top, partly onto a lovely soft alpaca Moebius scarf a kind reader sent me with a prescient note that said, "If you don't need this I hope your cat will like it," and partly on a little wool fetish-bear mat from the Southwest that a friend gave me. I never had a chance at the scarf. I opened the package at my desk. Pard came over and appropriated the scarf without a word. He dragged it a few inches

away from me, lay down on it, and began to knead it, looking dreamy and purring softly, till he went to sleep. It was his scarf. The mat arrived later, and was adopted as promptly: he sat on it. The cat sat on the mat. His mat. No argument. So the mat and scarf lie on the desk right by the warm Time Machine, and the cat distributes himself daily among the three of them, and purrs, and sleeps.

The other use he may have found for the Time Machine is purely, to me, speculative. It involves dematerialization.

Pard doesn't go outside often or stay long unless one of us is with him. He can't sleep outside, can barely lie down and half relax; he remains stimulated, watchful, jumpy. He has Indoors and those who share it with him pretty well under his paw, but he knows that Outdoors is way beyond his knowledge or control. He's not at home there. Wise little cat. So when now and then he vanishes, I don't much worry about his having somehow got out the back door and then found his cat flap locked; he's somewhere about the house.

But sometimes the disappearance goes on, and there is no Pard anywhere, outside or in. He is not in the basement, or the dark attic, or in a closet or a cupboard, or under a bedspread. He is not. He has dematerialized.

I get anxious and call his food call, ticky-ticky-ticky! and rattle the can of Greenies in an alluring fashion that would ordinarily bring him straight up or down the stairs without touching paw to stair.

Silence. Absence. No cat.

I tell myself to stop fretting, and Charles tells me to stop fretting, and I attempt or pretend to stop fretting, and go on with whatever I'm doing, fretting.

The sense of mystery is constant and oppressive.

And then, there he is. He has rematerialized before my eyes. There he is, with his tail curved over his back, and a bland, friendly expression suggesting permanent readiness for Food.

Pard, where were you?

Silence. Affable presence. Mystery.

I think he uses the Time Machine. I think it takes him elsewhere. Not cyberspace, that's no place for cats. Maybe he uses it to open temporal interstices, like the impossible window-frame nonspaces by which box elder beetles enter the house. By such secret ways, known to Bastet and Li Shou, lit by the stars of Leo, he visits that mysterious realm, that greater outdoors, where he is safe and perfectly at home.

Part Three

TRYING TO MAKE SENSE OF IT

A Band of Brothers,
a Stream of Sisters

November 2010

I HAVE COME to see male group solidarity as an immensely powerful force in human affairs, more powerful, perhaps, than the feminism of the late twentieth century took into account.

It's amazing, given their different physiology and complement of hormones, how much alike men and women are in most ways. Still it seems to be the fact that women on the whole have less direct competitive drive and desire to dominate, and therefore, paradoxically, have less need to bond with one another in ranked, exclusive groups.

The power of male group solidarity must come from the control and channeling of male rivalry, the repression and concentration of the hormone-driven will to dominate that so often dominates men themselves. It is a remarkable reversal. The destructive, anarchic energy of individual rivalry and competitive ambition is diverted into loyalty to group and leader and directed to more or less constructive social enterprise.

Such groups are closed, positing "the other" as outsider. They exclude, first, women; then, men of a different age, or kind, or caste, or nation, or level of achievement, etc.—exclusions

that reinforce the solidarity and power of the excluders. Perceiving any threat, the "band of brothers" joins together to present an impermeable front.

Male solidarity appears to me to have been the prime shaper of most of the great ancient institutions of society — Government, Army, Priesthood, University, and the new one that may be devouring all the others, Corporation. The existence and dominance of these hierarchic, organized, coherent, durable institutions goes back so far and has been so nearly universal that it's mostly just called "how things are," "the world," "the division of labor," "history," "God's will," etc.

As for female solidarity, without it human society, I think, would not exist. But it remains all but invisible to men, history, and God.

Female solidarity might better be called fluidity — a stream or river rather than a structure. The only institutions I am fairly sure it has played some part in shaping are the tribe and that very amorphous thing, the family. Wherever the male arrangement of society permits the fellowship of women on their own terms, it tends to be casual, unformulated, unhierarchical; to be ad hoc rather than fixed, flexible rather than rigid, and more collaborative than competitive. That it has mostly operated in the private rather than the public sphere is a function of the male control of society, the male definition and separation of "public" and "private." It's hard to know if women's groups would ever gather into great centers, because the relentless pressure from male institutions against such aggregation has prevented it. It might not happen anyhow. Instead of rising from the rigorous control of aggression in the pursuit of power, the energy of female solidarity comes from the wish and need for mutual aid and, often, the

search for freedom from oppression. Elusiveness is the essence of fluidity.

So when the interdependence of women is perceived as a threat to the dependence of women on men and the childbearing, child-rearing, family-serving, man-serving role assigned to women, it's easy to declare that it simply doesn't exist. Women have no loyalty, do not understand what friendship is, etc. Denial is an effective weapon in the hands of fear. The idea of female independence and interdependence is met with scoffing hatred by both men and women who see themselves as benefiting from male dominance. Misogyny is by no means limited to men. Living in "a man's world," plenty of women distrust and fear themselves as much or more than men do.

Insofar as the feminism of the 1970s played on fear, exalting the independence and interdependence of women, it was playing with fire. We cried "Sisterhood is powerful!"—and they believed us. Terrified misogynists of both sexes were howling that the house was burning down before most feminists found out where the matches were.

The nature of sisterhood is so utterly different from the power of brotherhood that it's hard to predict how it might change society. In any case, we've seen only a glimpse of what its effects might be.

The great ancient male institutions have been increasingly infiltrated by women for the last two centuries, and this is a very great change. But when women manage to join the institutions that excluded them, they mostly end up being co opted by them, serving male ends, enforcing male values.

Which is why I have a problem with women in combat in the armed services, and why I watch the rise of women in the "great"

universities and the corporations—even the government—
with an anxious eye.

Can women operate *as women* in a male institution without
becoming imitation men?

If so, will they change the institution so radically that the
men are likely to label it second-class, lower the pay, and aban-
don it? This has happened to some extent in several fields, such
as the practice of teaching and medicine, increasingly in the
hands of women. But the management of those fields, the power
and the definition of their aims, still belongs to men. The ques-
tion remains open.

As I look back on the feminism of the late twentieth century, I
see it as typical of feminine solidarity—all Indians, no chiefs.
It was an attempt to create an unhierarchical, inclusive, flexible,
collaborative, unstructured, ad hoc body of people to bring the
genders together in a better balance.

Women who want to work toward that end need, I think, to
recognize and respect their own elusive, invaluable, indestructi-
ble kind of solidarity—as do men. And they need to recognize
both the great value of male solidarity and the inferiority of gen-
der solidarity to human solidarity—as do men.

I think feminism continues and will continue to exist wher-
ever women work *in their own way* with one another and with
men, and wherever women and men go on questioning male
definitions of value, refusing gender exclusivity, affirming inter-
dependence, distrusting aggression, seeking freedom always.

Exorcists

November 2010

THE ROMAN CATHOLIC bishops of the United States are holding a conference on exorcism in Baltimore today and tomorrow. Many bishops and sixty priests are there to learn the symptoms of demonic possession—you may be possessed if you exhibit unusual strength, talk in a language you don't know, or react violently to anything holy—and the rites of exorcism, which include sprinkling holy water on you, laying hands on you, recitations, invocations, and blowing in your face.

The church updated the rite in 1999, advising that "all must be done to avoid the perception that exorcism is magic or superstition." This seems rather like issuing directions for driving a car while cautioning that all must be done to avoid the perception that a moving vehicle is being guided.

I'd advise weightlifters and people learning a foreign language to avoid Baltimore this weekend. I don't know how to advise people who react violently to anything holy. I don't know who they are, because I don't know what kind of violent reaction is meant, and because "what is holy" depends entirely on your perception of sacredness. If I am shaken by unutterably strong

emotion when I watch a pair of eagles dance with each other on the wind, or when I hear the first notes of the theme of the last movement of the Ninth Symphony, am I possessed by a demon? I don't know, but I'm staying away from Baltimore.

I think the people who should hurry there are the four male Catholic judges of the United States Supreme Court, all of whom are adherents of the policies of Pope Ratzinger and members of the ultra-reactionary Catholic group Opus Dei. Exorcism lessons should enrich their repertory no end. The fifth Roman Catholic on the Supreme Court is a woman, and thereby excluded from doing the "work of God."

Uniforms

February 2011

THE UNITED STATES went to war with Germany and Japan when I was a kid of eleven. One of the things I remember is how—overnight, it seemed to me—the streets of Berkeley filled up with uniforms. All during the war, men in civvies were in the minority downtown. But the uniforms didn't bring uniformity into the city. If anything, they were an improvement on the drab, same-old clothing of the end of the Great Depression.

The army and army air force wore khaki in various shades of brown, greenish, and tan: handsome jackets, creased pants, shined black shoes, all very trim. But never quite a match for the navy uniforms, the gobs in their white tunics and pants and little round white hats in summer, and in winter, blue wool tunics with a sailor collar and pants with a thirteen-button, square flap fly, I kid you not. Cute little round butts looked terrific in that uniform. And the officers in their crisp white or navy blue, gold buttons, gold braid, were a breed apart, sharp as tacks. There were no Marine bases near Berkeley that I know of; anyway we didn't see Marines around much, but they looked quite grand in the newsreels.

My brother Clif's ship was commissioned in San Francisco Harbor and we went to the ceremony: a fine show, formal, traditional, embellished by those dandy dress uniforms. The men looked terrific lined up there on the deck, all blue and white and gold in the sun. What boy wouldn't want to look like that, and be seen looking like that by everybody?

A uniform, ever since the eighteenth century, when they first really started inventing them, has been known as a powerful aid to recruitment.

I can't say that that was true for the uniforms women got handed in WWII. They imitated the men's, of course, with skirts instead of pants, but were poorly designed, the taut, snappy look becoming tight and stiff on women; even granted the severe rationing of cloth, the uniforms were unnecessarily skimpy, prim, and awkward. I certainly wouldn't have joined the WAVES or the WAC for the uniform, only in spite of it. Fortunately for the WAVES, the WAC, and me, I was fifteen when the war ended.

During the next several American wars, the whole concept of the uniform evolved away from good fit and good looks toward a kind of aggressively practical informality, or sloppiness, or slobbishness. By now our soldiers are mostly seen in shapeless, muddy-looking spotted pajamas.

This uniform may be useful and comfortable in the jungles of Vietnam or the deserts of Afghanistan. But do men need camouflage when flying from Reno to Cincinnati, or combat boots on Fifth Avenue? I guess soldiers still have dress uniforms—I know the Marines do, they seem to put them on way more often than the other services, maybe because they get so many photo ops in D.C.—but I can't remember when I last saw an army private on the street looking sharp.

I know that for many boys and men, camo has taken on the

glamour that a handsome uniform once had. Grotesque as it appears to me, it looks manly and fine to them. So I guess the uniform still serves as an aid to recruitment, luring the boy who wants to wear it, look like that, be that soldier. And I don't doubt that young men wear it with pride.

But I wonder very much about the effect of the camo-pajama uniform on most civilians. I find it not only degrading but disturbing that we dress up our soldiers in clothes suitable to jail or the loony bin, setting them apart not by looking good, looking sharp, but by looking like clowns from a broken-down circus.

This whole change in style of uniforms may be part of a change in our style of war, and with it a changed attitude toward service in the military. Possibly it reflects a newly realistic opinion of war, a refusal to glamorize it. If we cease to see war as an inherently noble and ennobling thing, we cease to put the warrior on a pedestal. Handsome uniforms then seem a mere parade, a false front for the senseless brutality of behavior in war. So "fatigues" can be grossly utilitarian, with no thought for the appearance or self-esteem of the wearer. Anyhow, now that most war is waged not between armies but by machines killing civilians, what's the meaning of a military uniform at all? Didn't the child dead in the ruins of a bombed village die for her country just as any soldier does?

But I can't believe the army thinks that way, that it's making uniforms ugly in order to encourage us to think war is ugly. Perhaps the fatigue uniform reflects an attitude they aren't conscious of and would never admit, a change less in the nature of war than in our national attitude to it, which is neither glamorizing nor realistic but simply uncaring. We pay very little attention to our wars or to the people fighting them.

Right or wrong, in the 1940s we honored our servicemen.

We were in that war with them. Most of them were draftees, some quite unwilling ones, but they were our soldiers and we were proud of them. Right or wrong, since the 1950s and particularly since the 1970s, we began putting whichever war was on at the moment out of sight and out of mind, and with it the men and women fighting it. These days they're all volunteers. Yet— or therefore?—we disown them. We give them pro forma praise as our brave defenders, send them over to whichever country we're fighting in now, keep sending them back over, and don't think about them. They aren't us. They aren't people we really want to see. Like the people in jails, the people in loony bins. Like clowns that aren't funny, from a third-rate circus we wouldn't think of going to.

Now shall we talk about how much we pay, how we are bankrupting our future, to keep that circus going?

No. That's not something we talk about. Not in Congress. Not in the White House. Not anywhere.

Clinging Desperately to a Metaphor

September 2011

> Unless the people benefit, economic growth is a subsidy for
> the rich.
> —Richard Falk, "Post-Mubarak Revolutionary Chances,"
> *Al Jazeera,* 22 February 2011

IT'S AS SILLY for me to write about economics as it would be
for most economists to write about the use of enjambment in
iambic pentameter. But they don't live in a library, and I do live
in an economy. Their life can be perfectly poetry-free if they like,
but my life is controlled by their stuff whether I like it or not.

So: I want to ask how economists can continue to speak of
growth as a positive economic goal.

I understand why we're in a panic when our business or our
whole economy goes into a decline or a recession: because the
whole system is based on keeping up with/outgrowing the com-
petition, and if we fail to do that, we face hard times, collapse,
crash.

But why do we never question the system itself, so as to find
ways to get around it or out of it?

Up to a point, growth is a plausible metaphor. Living things need to grow, first to their optimum size, and then to keep replacing what wears out, annually (as with many plants) or continually (as with mammalian skin). A baby grows to adult size, after which growth goes to maintaining stability, homeostasis, balance. Growth much beyond that leads to obesity. For a baby to grow endlessly bigger would be first monstrous, then fatal.

In taking uncontrolled, unlimited, unceasing growth as the only recipe for economic health, we've dismissed the ideas of optimum size and keeping the organism in balance.

Maybe there are organisms that have no optimum size, like the enormous fungal network one hears about that underlies the whole Middle West, or is it just Wisconsin? But I wonder if a fungus wandering around thousands of square miles underground is the most promising model for a human economy.

Some economists prefer to use mechanical terms, but I believe machines have an optimum size much as living organisms do. A big machine can do more work than a small one, up to a point, beyond which things like weight and friction begin to ruin its efficiency. The metaphor comes up against the same limit.

Then there's social Darwinism—bankers red in tooth and claw, surviving fitly, while small vermin live on the blood that trickles down... This metaphor, based on a vast misunderstanding of evolutionary process, hits its limit almost at once. In predatory competition, bigness is useful, but there are endless ways to get your dinner besides being bigger than it is. You can be smaller but smarter, smaller but faster, tiny but poisonous, winged... you can live inside it while you eat it... As for getting a mate, if combat were the only way to score, large size would help, but (despite our battle fixation) most competition doesn't involve combat. You can win the reproductive race by dancing

gracefully, by having a blue-green tail decorated with eyes, by building a lovely bower for your bride, by knowing how to tell a joke ... As for living space, you can crowd out your neighbors by outgrowing them, but it's cheaper and just as effective to corner all the water in the vicinity, like a juniper tree, or to be toxic to sea anemones who aren't closely related to you ... The competitive techniques of plants and animals are endless in variety and ingenuity. So why are we, clever we, stuck on one and one only?

An organism that settles on a single survival stratagem and ceases to seek and find others—ceases to adapt—is at high risk. And adaptability is our principle and most reliable gift. As a species we are almost endlessly, almost appallingly adaptable. Capitalism thinks it's adaptable, but if it only has one stratagem, endless growth, the limit of its adaptability is irrevocably set. And we have reached that limit. We are therefore at very high risk.

Capitalist growth, probably for at least a century and certainly from the turn of the millennium on, has been growth in the wrong sense. Not only endless but uncontrolled—random. Growth as in tumor. Growth as in cancer.

Our economy isn't just in a recession. It is sick. As a result of uncontrolled economic (and population) growth, our ecology is sick, and getting sicker every day. We have disturbed the homeostasis of the earth, the ocean, and the atmosphere—not fatally to life on the planet; the bacteria will survive the corporation. But perhaps fatally to ourselves.

We have been in denial about this for decades. By now the denials are hysterical in every sense of the word—*What do you mean, climate instability? What do you mean, overpopulation? What do you mean, reactors are toxic? What do you mean, you can't live on corn syrup?*

We go on mechanically repeating the behaviors that caused

the sickness: we bail out the bankers, we resume offshore drill-
ing, we pay polluters to pollute, because without them how is
our economy to grow? Yet increasingly, all economic growth
benefits only the rich, while most people grow poorer. The Eco-
nomic Policy Institute reports:

> From 2000 to 2007 (the last period of economic growth
> before the current recession) the richest 10% of Americans
> received 100% (one hundred percent—all) the average
> growth of income. The other 90% received none.

At this rate, by the time we admit that cancer is not health,
that we're sick, any cure must be so radical as almost certainly
to require dictatorial rule, and to destroy more—physically and
morally—than it can save.

Nobody in any government seems able even to imagine al-
ternatives, and people who talk about them get little attention.
Some of the alternatives that existed in the past had promise;
I think socialism did, and still does, but it was run off the rails
by ambitious men using it as a means to power, and by the in-
fection of capitalism—the obsession with growing bigger at all
cost in order to defeat rivals and dominate the world. The exam-
ple of the larger socialist states is about as heartening as that of
the giant underground fungus.

So what is our new metaphor to be? It might be the differ-
ence between life and death to find the right one.

Lying It All Away

October 2012

I'M FASCINATED BY this historical snippet from the *New York Times*'s "On This Day" feature:

> On October 5, 1947, in the first televised White House address, President Truman asked Americans to refrain from eating meat on Tuesdays and poultry on Thursdays to help stockpile grain for starving people in Europe.

The first televised White House address — that's interesting. Imagine a world in which a president speaks to the people on the radio, or can speak only to a physically present audience, like Lincoln at Gettysburg. How quaint, how primitive, how different from us, were those simple folk of olden days!

But that's not what fascinates me in this item. What I'm working hard to imagine or remember is a country whose president asked his people not to eat beef on Tuesdays or chicken on Thursdays because there were people starving in Europe. The Second World War had left the European economy as well as its cities pretty much in ruins, and this president thought Americans would a) see the connection between meat and grain, and b)

be willing to forgo a luxury element of their diet in order to give away a more essential food to hungry foreigners on another continent, some of whom we'd been killing, and some of whom had been killing us, two years earlier.

At the time, the request was laughed or sneered at by some and ignored by most. But still: can you imagine any president, now, asking the American people to deprive themselves of meat once or twice a week in order to stockpile grain to ship to hungry foreigners on another continent, some of them no doubt terrorists?

Or asking us to refrain from meat now and then to provide more grain to programs and food banks for the 20,000,000 Americans living in "extreme poverty" (which means malnutrition and hunger) right now?

Or, actually, asking us to do without anything for any reason?

Something has changed.

Since our betrayed public schools can no longer teach much history or reading, people may find everyone and everything before about twenty-five years ago unimaginably remote and incomprehensibly different from themselves. They defend their discomfort by dismissing people before their time as simple, quaint, naive, etc. I know Americans sixty-five years ago were nothing of the sort. Still, that speech of Harry Truman's tells me something has indeed changed.

Being very old, I remember a little about the Depression, and a lot about the Second World War and its aftermath, and some things about Lyndon Johnson's "war on poverty," and so on. This experience doesn't allow me to ever take prosperity for all as a fact—only an ideal. But the success of the New Deal and the socioeconomic network set in place after 1945 allowed a lot of peo-

ple to assume almost unthinkingly that the American Dream had come to pass and would go on forever. Only now is a whole generation maturing that didn't grow up in the alluring stability of steady inflation, but has seen growth capitalism return to its origins, providing security for none but the strongest profiteers. In this respect, the experience of my grandchildren is and will be very different from that of their parents, or mine. I wish I could live to see what they're going to do about it.

But this still doesn't quite take me to whatever it is about that request of old Harry's that intrigues me so, and that, when I think about it, makes me feel as if the America I'm living in is somebody else's country.

An education that gave me a sense of the continuity of human life and thought keeps me from dividing time into Now (Us—the last few years) and Then (Them—history). A glimmer of the anthropological outlook keeps me from believing that life was ever simple for anybody, anywhere, at any time. All old people are nostalgic for certain things they knew that are gone, but I live in the past very little. So why am I feeling like an exile?

I have watched my country accept, mostly quite complacently, along with a lower living standard for more and more people, a lower moral standard. A moral standard based on advertising. That hard-minded man Saul Bellow wrote that democracy is propaganda. It gets harder to deny that when, for instance, during a campaign, not only aspirants to the presidency but the president himself hides or misrepresents known facts, lies deliberately and repeatedly. And only the opposition objects.

Sure, politicians always lied, but Adolf Hitler was the first one who made it into a policy. American politicians didn't use to lie as if they knew that nobody cared whether they lied or not, though Nixon and Reagan began testing those waters of moral

indifference. Now we're deep in them. What was appalling to me about Obama's false figures and false promises in the first debate was that they were *unnecessary*. If he'd told the truth, he would have supported his candidacy better, as well as putting Romney's faked figures and evasive vagueness to shame. He would have given us a moral choice instead of a fudge-throwing match.

Can America go on living on spin and illusion, hot air and hogwash, and still be my country? I don't know.

I guess it's become improbable even to me that a president should ever have asked Americans not to eat chicken on Thursdays. Maybe it is quaint, after all. "My fellow Americans, ask not what your country can do for you—ask what you can do for your country." Yeah, uh-huh. Oh boy! That one did some fancy lying too. Still, he talked to us as adults, citizens capable of asking difficult questions and deciding what to do about them—not as mere consumers capable of hearing only what we want to hear, incapable of judgment, indifferent to fact.

What if some president asked those of us who can afford to eat chicken not to eat chicken on Thursdays so the government could distribute more food to those 20,000,000 hungry members of our community? Come off it. Goody-goody stuff. Anyhow, no president could get that past the corporations of which Congress is an almost wholly owned subsidiary.

What if some president asked us (one did, once) to accept a 55 mph speed limit in order to save fuel, roads, and lives? Chorus of derisive laughter.

When did it become impossible for our government to ask its citizens to refrain from short-term gratification in order to serve a greater good? Was it around the time we first began hearing about how no red-blooded freedom-loving American should have to pay taxes?

I was certainly never in love with the mere idea of "doing without," as Puritans are. But I admit I'm depressed by the idea that we can't even be asked to consider doing without in order to give or leave enough for people who need it or will need it, including, possibly, ourselves. Is the red-blooded freedom-loving American so infantile that he has to be promised whatever he wants right now this moment? Or, to put it less fancifully, if citizens can't be asked to refrain from steak on Tuesdays, how can industries and corporations be asked to refrain from the vast and immediate profits they make from destabilizing the climate and destroying the environment?

It appears that we've given up on the long-range view. That we've decided not to think about consequences—about cause and effect. Maybe that's why I feel that I live in exile. I used to live in a country that had a future.

If and when we finish degrading the environment till we run out of meat and the rest of the luxury foods, we'll learn to do without them. People do. The president won't even need to ask. But if and when we run out of things that are not a luxury, like water, will we be able to use less, to do without, to ration, to share?

I wish we were getting a little practice in such things. I wish our president would respect us enough to give us a chance to practice at least thinking about them.

I wish the ideals of respecting truth and sharing the goods hadn't become so foreign to my country that my country begins to seem foreign to me.

The Inner Child and the
Nude Politician

October 2014

LAST SUMMER A COMPANY that makes literary T-shirts asked me for permission to use a quote:

> "The creative adult is the child who survived."

I looked at the sentence and thought, Did I write that sentence? I think I wrote something like it. But I hope not that sentence. *Creative* is not a word I use much since it was taken over by corporationthink. And isn't *any* adult a child who survived?

So I Googled the sentence. I got lots of hits, and boy were some of them weird. In many of them the sentence is ascribed to me, but no reference to a source is ever given.

The weirdest one is at a site called quotes-clothing.com:

> MY DEAR,
> *The creative adult is the child who survived.*
>
> The creative adult is the child who survived after the world tried killing them, making them "grown up." The creative adult is the child who survived the blandness of schooling, the unhelpful words of bad teachers, and the nay-saying ways of the world.

The creative adult is in essence simply that, a child.

Falsely yours,

URSULA LE GUIN

The oddest part of this little orgy of self-pity is "Falsely yours," which I take to be a coy semiconfession of forgery by whoever actually wrote the rant.

I've looked through my own essays for the sentence that could have been used or misused for the quote, because I still have a feeling there is one. So far I haven't found it. I asked my friends in an sf chat group if it rang any bell with them — some of them being scholars, with a keen nose for provenience — but none of them could help. If anybody reading this has a theory about the origin of the pseudo-quote, or better yet a Eureka! with volume and page citation, would you please post it as a response at BVC? Because it's been bothering me ever since June.*

The sentence itself, its use and popularity, bothers me even more. Indifference to what words actually say; willingness to ac-

* Welcome responses to this blog post on Book View Café soon gave me both the sentence I wrote and a possible source of the misquotation. In the 1974 essay "Why Are Americans Afraid of Dragons?" (reprinted in the collection *The Language of the Night*), I wrote: "I believe that maturity is not an outgrowing, but a growing up: that an adult is not a dead child, but a child who survived." Nothing about "creativity" whatever. I was just hitting at the notion that maturity is mere loss or betrayal of childhood. The misquote may have first appeared on the Internet in 1999, in a huge and generally useful collection of quotations compiled by Professor Julian F. Fleron. When I wrote him, he was distressed to learn that it was a misquote, and most amiably removed it at once. But a false attribution on the Internet is like box elder beetles, the miserable little things just keep breeding and tweeting and crawling out of the woodwork. I checked just now (July 2016): Goodreads and AIGA continue to attribute the "creative adult" misquote to me. It has also taken on an independent existence, and is even referred to by one source as "the well-known saying." Oh well!

cept a vapid truism as a useful, even revelatory concept; care-lessness about where a supposed quotation comes from—that's all part of what I like least about the Internet. A "blah blah blah, who cares, information is what I want it to be" attitude—a lazy-mindedness that degrades both language and thought.

But deeper than that lies my aversion to what the sentence says to me: that *only* the child is alive and creative—so that to grow up is to die.

To respect and cherish the freshness of perception and the vast, polymorphous potentialities of childhood is one thing. But to say that we experience true being only in childhood and that creativity is an infantile function—that's something else.

I keep meeting this devaluation of growing up in fiction, and also in the cult of the Inner Child.

There's no end of books for children whose hero is a rebellious misfit—the boy or girl (usually described as plain, and almost predictably red-haired) who gets into trouble by questioning or resisting or ignoring The Rules. Every young reader identi-fies with this kid, and rightly. In some respects, to some extent, children *are* victims of society: they have little or no power; they aren't given the chance to show what's in them.

And they know it. They love reading about taking power, getting back at bullies, showing their stuff, getting justice. They want to do so so that they can grow up, claim independence in order to take responsibility.

But there's a literature written for both kids and adults in which human society is reduced to the opposition Kids Good/Creative, Adults Bad/Dead Inside. Here the child heroes are not

only rebellious but are in all ways superior to their hidebound, coercive society and the stupid, insensitive, mean-minded adults that surround them. They may find friendship with other children, and understanding from a wise, grandparently type of another skin color or from people marginal to or outside their society. But they have nothing to learn from adults of their own people, and those elders have nothing to teach them. Such a child is always right, and wiser than the adults who repress and misunderstand him. Yet the super-perceptive, wise child is helpless to escape. He is a victim. Holden Caulfield is a model of this child. Peter Pan is his direct ancestor.

Tom Sawyer has something in common with this kid, and so does Huck Finn, but Tom and Huck are not sentimentalized or morally oversimplified, nor do they consent to be victims. They are described with, and have, a powerful sense of ironic humor, which affects the crucial issue of self-pity. The coddled Tom loves to see himself as cruelly oppressed by meaningless laws and obligations, but Huck, a real victim of personal and social abuse, has no self-pity at all. Both of them, however, fully intend to grow up, to take charge of their own lives. And they will—Tom no doubt as a successful pillar of his society, Huck a freer man, out there in the Territories.

It seems to me the Super-Perceptive Child Victim of Self-Pity has something in common with the Inner Child: they're lazy. It's so much easier to blame the grownups than to be one.

The idea that we all contain an Inner Child who has been suppressed by our society, the belief that we should cultivate this Inner Child as our true self and that we can depend upon it to

release our creativity, seems an overreductive statement of an insight expressed by many wise and thoughtful people—among them Jesus: "Except ye be converted and become as little children, ye shall not enter the kingdom of heaven."

Some mystics and many great artists, aware of drawing on their childhood as a deep source of inspiration, have spoken of the need to maintain an unbroken inner connection between the child and the adult in one's own inward life.

But to reduce this to the idea that we can open a mental door from which our imprisoned Inner Child will pop out and teach us how to sing, dance, paint, think, pray, cook, love, etc. . . . ?

A very wonderful statement of the necessity, and the difficulty, of maintaining a connection to one's own child-self is Wordsworth's "Ode on Intimations of Immortality." The poem offers a profoundly felt, profoundly thoughtful, radical argument:

> Our birth is but a sleep and a forgetting . . .

Instead of seeing birth as an awakening from blank non-being and fetal incompletion into the child's fullness of being, and seeing maturity as a narrowing, impoverishing journey toward blank death, the ode proposes that a soul enters life forgetting its eternal being, can remember it throughout life only in intimations and moments of revelation, and will recall and rejoin it fully only in death.

Nature, says Wordsworth, offers us endless reminders of the eternal, and we are most open to them in our childhood. Though we lose that openness in adult life, when "custom" lies upon us "with a weight/heavy as frost, and deep almost as life," still we can keep faith with

> *Those shadowy recollections,*
> *Which, be they what they may,*
> *Are yet the fountain-light of all our day,*
> *Are yet a master-light of all our seeing;*
> *Uphold us, cherish, and have power to make*
> *Our noisy years seem moments in the being*
> *Of the eternal Silence: truths that wake*
> *To perish never.*

I cherish this testimony particularly because it need not be seen as rising from the belief system of any religion. Believer and freethinker can share this vision of human existence passing from light through darkness into light, from mystery to endless mystery.

In this sense, the innocence, the unjudging, unqualified openness to experience of the young child, can be seen as a spiritual quality attainable or reattainable by the adult. And I think this is what the idea of the Inner Child originally, or optimally, is all about.

But Wordsworth makes no sentimental plea to us to nourish the child we were by denying the value of maturity or by trying to *be* a child again. However conscious we are of the freedom and awareness and joyfulness we lose as we age, we live a full human life not by stopping at any stage, but by becoming all that is in us to become.

> *Though nothing can bring back the hour*
> *Of splendour in the grass, of glory in the flower,*
> *We will grieve not, rather find*
> *Strength in what remains behind;*
> *In the primal sympathy*

Which having been must ever be;
In the soothing thoughts that spring
Out of human suffering;
In the faith that looks through death;
In years that bring the philosophic mind.

(If, like me, you look at that word *soothing* in surprise, wondering how thoughts of human suffering can be soothing, perhaps you will feel as I do that such wonder is a key—a sign that the poet's direct language contains immensely more than its apparent clarity reveals at first, that nothing he says in this poem is simple, and that though it's easily understood, any understanding of it may lead on, if followed, to further understanding.)

The cult of the Inner Child tends to oversimplify what Wordsworth leaves complex, close off what he leaves open, and make oppositions where there are none. The child is good—therefore the adult is bad. Being a kid is great—so growing up is the pits.

Sure enough, growing up isn't easy. As soon as they can toddle, babies are bound to toddle into trouble. Wordsworth had no illusions about that: "Shades of the prison-house begin to close/ upon the growing Boy . . ." The transition to adulthood, adolescence, is difficult and dangerous, recognized as such by many cultures—all too often in punitive ways such as cruel male initiation rites, or the brutal eradication of adolescence in girls by marrying them off as soon as they menstruate.

I see children as unfinished beings who have been given a very large job to do. Their job is to become complete, to fulfill their potential: to grow up. Most of them want to do this job and try their level best to do it. All of them need adult help in doing it. This help is called "teaching."

Teaching can of course go wrong, be restrictive not educative, be stultifying, cruel. Everything we do can be done wrong. But to dismiss teaching as a mere repression of childish spontaneity is a monstrous injustice to every patient parent and teacher in the world since the Old Stone Age, and denies both children's right to grow up and their elders' responsibility to help them do so.

Children are by nature, by necessity, irresponsible, and irresponsibility in them, as in puppies or kittens, is part of their charm. Carried into adulthood it becomes a dire practical and ethical failing. Uncontrolled spontaneity wastes itself. Ignorance isn't wisdom. Innocence is wisdom only of the spirit. We can and do all learn from children, all through our life; but "become as little children" is a spiritual counsel, not an intellectual, practical, or ethical one.

In order to see that our emperors have no clothes on, do we really have to wait for a child to say so? Or even worse, wait for somebody's Inner Brat to pipe up? If so, we're in for a lot of nude politicians.

A Modest Proposal: Vegempathy

June 2012

IT IS TIME for humanity to ascend from our primitive condition as omnivores, carnivores, vegetarians, and vegans. We must take the inevitable next step to Oganism — the Way of the Aerovore — leading away from obesity, allergy, and cruelty toward blameless purity. Our motto must be *All we need is O.*

Many people troubled by the suffering of animals — animals who would scarcely exist outside zoos if we did not breed them for their meat, milk, and eggs — remain strangely indifferent to the endless, enormous ordeal of the vegetables we keep in captivity or capture wild. Consider, for one moment, what plants undergo at our hands. We breed them with ruthless selectivity, harass, torment, and poison them, crowd them into vast monocultures, caring for their well-being only as it affects our desires, raising many merely for their byproducts such as seed, flower, or fruit. And we slaughter them without a thought of their suffering when "harvested," uprooted, torn living from their earth or branch, slashed, chopped, mown, ripped to pieces — or when "cooked," dropped to die in boiling water or oil or an oven — or,

worst of all, eaten raw, stuffed into a human mouth and masticated by human teeth and swallowed, often while alive.

Do you think a bean is dead because you bought it at the store in a plastic bag? That a carrot is dead because it's been in the refrigerator for a while? Have you ever planted a few of those beans in damp earth and waited a week or two, put the carrot top in a saucer of fresh water and waited a week or two?

The life in a plant may be less visible but far more intense and durable than the life in an animal. If you put an oyster in a saucer of fresh water and keep it for a week, the result will be quite different.

Why then, if it is immoral to subject an oyster to the degradation of becoming food, is it blameless, even virtuous, to do the same thing to a carrot or a piece of tofu?

"Because the carrot doesn't suffer," says the vegan. "Soybeans have no nervous system. They don't feel pain. Plants have no feelings."

That is exactly what many people said about animals for millennia, and what many still say about fish. As science has brought us — some of us — back to an awareness of our animality, we have been forced to acknowledge that all higher animals suffer pain and fear at least as intensely as we do. But just as we once misused science to support the claim that animals are mindless machines, so now we misuse science to support the claim of knowing that nonanimal living things — plants — have no feelings.

We know nothing of the sort.

Science has only just begun to investigate plant sensitivity and plant communication. The results are still meager, but positive, fascinating, and strange. The mechanisms and processes,

being so very different from the senses and nervous systems of animals, are barely understood,. But so far what science has to say on the subject fails to justify the convenient belief that plants are insensate. We don't know what the carrot feels.

In fact, we don't know what the oyster feels. We can't ask the cow's opinion on being milked, although we can hypothesize that if her udder was full she might feel relief. The assumptions we make about all other living creatures are mostly self-serving. And perhaps the most deeply entrenched of them is that plants are insensate, irrational, and dumb: thus "inferior to" animals, "here for our use." This snap judgment allows even the most tenderhearted of us to disrespect plants, to kill vegetables without mercy, to congratulate ourselves on the purity of our conscience while in the very act of callously devouring a young kale stalk or a tender, delicate, curling, living, infant pea tendril.

I believe the only way to avoid such cruel hypocrisy and achieve true clarity of conscience is by becoming an Ogan.

It is a pity that the Ogan movement by its nature and principles is fated to be, in each individual case, rather short-lived. But surely the first martyrs of the cause will inspire multitudes to follow them in forswearing the grossly unnatural practice of supporting life by eating other living beings or their byproducts. Ogans, ingesting only the unsullied purity of the O in the atmosphere and in H_2O, will live in true amity with all animals and all vegetables, and will proudly preach their creed for as long as they possibly can. It could be for several weeks, sometimes.

Belief in Belief

February 2014

YOU CAN BUY rocks in which are carved words intended to be inspiring — LOVE, HOPE, DREAM, etc. Some have the word BE-LIEVE. They puzzle me. Is belief a virtue? Is it desirable in itself? Does it not matter what you believe so long as you believe something? If I believed that horses turned into artichokes on Tuesdays, would that be better than doubting it?

Charles Blow had a fine editorial in the *New York Times* on January 3, 2014, "Indoctrinating Religious Warriors," indicting the radical Republicans' use of religion to confuse opinion on matters of fact and their success in doing so. He used a Pew report from December 30, 2013, to provide this disheartening statistic:

> Last year . . . the percentage of Democrats who believed in evolution inched up to 67 percent, the percentage of Republicans believing so plummeted to 43 percent. Now, more Republicans believe that "humans and other living things have existed in their present form since the beginning of time" than believe in evolution.

Now, greatly as I respect Charles Blow's keen intelligence and reliable compassion, his choice of words here worries me. Four times in this paragraph he uses the verb *believe* in a way that implies that the credibility of a scientific theory and the credibility of a religious scripture are comparable.

I don't think they are. And I want to write about it because I agree with him that issues of factual plausibility and spiritual belief or faith are being—cynically or innocently—confused, and need to be disentangled.

I wasn't able to find the exact wording of the questions asked in the Pew survey.

Their report uses the word *think* more often than *believe*—people "think" that human and other beings have evolved over time, or "reject the idea."

This language reassures me somewhat. For if a poll-taker asked me, "Do you believe in evolution?" my answer would have to be "No."

I ought to refuse to answer at all, of course, because a meaningless question has only meaningless answers. Asking me if I believe in evolution, in change, makes about as much sense as asking if I believe in Tuesdays, or artichokes. The word *evolution* means change, something turning into something else. It happens all the time.

The problem here is our use of the word *evolution* to signify *the theory of evolution*. This shorthand causes a mental short circuit: it sets up a false parallel between a hypothesis (concerning observed fact) and a revelation (from God, as recorded in the Hebrew Bible)—which is then reinforced by our loose use of the word *believe*.

I don't *believe* in Darwin's theory of evolution. I *accept* it. It isn't a matter of faith, but of evidence.

The whole undertaking of science is to deal, as well as it can, with reality. The reality of actual things and events in time is subject to doubt, to hypothesis, to proof and disproof, to acceptance and rejection—not to belief or disbelief.

Belief has its proper and powerful existence in the domains of magic, religion, fear, and hope.

I see no opposition between accepting the theory of evolution and believing in God. The intellectual acceptance of a scientific theory and the belief in a transcendent deity have little or no overlap: neither can support or contradict the other. They rise from profoundly different ways of looking at the same world—different ways of coming at reality: the material and the spiritual. They can and often do coexist in perfect harmony.

Extreme literalism in reading religious texts makes any kind of thinking hard. Still, even if one believes that God created the universe in six days a few thousand years ago, one can take that as a spiritual truth unaffected by the material evidence that the universe is billions of years old. And vice versa: as Galileo knew, though the Inquisitors didn't, whether the earth goes round the sun or the sun goes round the earth doesn't affect one way or the other the belief that God is the spiritual center of all.

The idea that only belief sees the world as wonderful, and the "cold hard facts" of science take all the color and wonder out of it, the idea that scientific understanding automatically threatens and weakens religious or spiritual insight, is just hokum.

Some of the hokum arises from professional jealousy, rivalry, and fear—priest and scientist competing for power and control of human minds. Atheist rant and fundamentalist rant ring alike: passionate, partial, false. My impression is that most working scientists, whether they practice a religion or not, accept the coexistence of religion, its primacy in its own sphere,

and go on with what they're doing. But some scientists hate religion, fear it, and rail against it. And some priests and preachers, wanting their sphere of influence to include everything and everyone, claim the absolute primacy of biblical revelation over material fact.

Thus they both set a fatal trap for the believer: if you believe in God you can't believe in evolution, and vice versa.

But this is rather like saying if you believe in Tuesday you can't believe in artichokes.

Maybe the problem is that believers can't believe that science doesn't involve belief. And so, confusing knowledge with hypothesis, they fatally misunderstand what scientific knowledge is and isn't.

A scientific hypothesis is a tentative assertion of knowledge based on the observation of reality and the collection of factual evidence supporting it. Assertions without factual content (beliefs) are simply irrelevant to it. But it's always subject to refutation. The only way to refute it is to come up with observed facts that disprove it.

So far, evidence fully supports the hypothesis that Creation has been changing since its origin, that on earth living creatures, adapting to change, have evolved through eons from single-cell organisms through a vast profusion of species, and that they're still adapting and evolving right now (as can be seen in the evolution of finch species in the Galápagos, or moth coloration, or barred/spotted owl interbreeding, or a hundred other examples).

Yet to the strict scientific mind, the theory of evolution is not absolute knowledge. Exhaustively tested and supported by evidence as it is, it's a theory: further observation can always alter,

improve, refine, or enlarge it. It's not dogma, it's not an article of faith, but a tool. Scientists use it, act on it, even defend it as if they believed in it, but they're not doing so because they take it on faith. They accept it and use it and defend it against irrelevant attack because it has so far withstood massive attempts at disproof, and because it works. It does a necessary job. It explains things that needed explaining. It leads the mind on into new realms of factual discovery and theoretical imagination.

Darwin's theory vastly enlarges our perception of reality — our always tentative knowledge. As far as we have tested it and can test it, and always subject to modification as we learn more, we can accept it as true knowledge — a great, rich, beautiful insight. Not a revealed truth, but an earned one.

In the realm of the spirit, it appears that we can't earn knowledge. We can only accept it as a gift: the gift of belief. *Belief* is a great word, and a believed truth too can be great and beautiful. It matters very greatly what one believes in.

I wish we could stop using the word *belief* in matters of fact, leaving it where it belongs, in matters of religious faith and secular hope. I believe we'd avoid a lot of unnecessary pain if we did so.

About Anger

October 2014

I. *SAEVA INDIGNATIO*

In the consciousness-raising days of the second wave of feminism, we made a big deal out of anger, the anger of women. We praised it and cultivated it as a virtue. We learned to boast of being angry, to swagger our rage, to play the Fury.

We were right to do so. We were telling women who believed they should patiently endure insults, injuries, and abuse that they had every reason to be angry. We were rousing people to feel and see injustice, the methodical mistreatment to which women were subjected, the almost universal disrespect of the human rights of women, and to resent and refuse it for themselves and for others. Indignation, forcibly expressed, is an appropriate response to injustice. Indignation draws strength from outrage, and outrage draws strength from rage. There is a time for anger, and that was such a time.

Anger is a useful, perhaps indispensable tool in motivating resistance to injustice. But I think it is a weapon—a tool useful only in combat and self-defense.

People to whom male dominance is important or essential fear women's resistance, therefore women's anger—they know a weapon when they see one. The backlash from them was immediate and predictable. Those who see human rights as consisting of men's rights labeled every woman who spoke up for justice as a man-hating, bra-burning, intolerant shrew. With much of the media supporting their view, they successfully degraded the meaning of the words *feminism* and *feminist*, identifying them with intolerance to the point of making them almost useless, even now.

The far right likes to see everything in terms of warfare. If you look at the feminism of 1960–1990 that way, you might say it worked out rather like the Second World War: the people who lost it gained a good deal, in the end. These days, overt male dominance is less taken for granted; the gender gap in take-home pay is somewhat narrower; there are more women in certain kinds of high positions, particularly in higher education; within certain limits and in certain circumstances, girls can act uppity and women can assume equality with men without risk. As the old ad with the cocky bimbo smoking a cigarette said, You've come a long way, baby.

Oh gee, thanks, boss. Thanks for the lung cancer too.

Perhaps—to follow the nursery metaphor instead of the battlefield one—if feminism was the baby, she's now grown past the stage where her only way to get attention to her needs and wrongs was anger, tantrums, acting out, kicking ass. In the cause of gender rights, mere anger now seldom proves a useful tool. Indignation is still the right response to indignity, to disrespect, but in the present moral climate it seems to be most effective expressed through steady, resolute, morally committed behavior and action.

This is clearly visible in the issue of abortion rights, where the steadfast nonviolence of rights defenders faces the rants, threats, and violence of rights opponents. The opponents would welcome nothing so much as violence in return. If NARAL vented rage as Tea Party spokesmen do, if the clinics brandished guns to defend themselves from the armed demonstrators, the opponents of abortion rights on the Supreme Court would hardly have to bother dismantling *Roe vs. Wade* by degrees, as they're doing. The cause would be already lost.

As it is, it may suffer a defeat, but if we who support it hold firm it will never be lost.

Anger points powerfully to the denial of rights, but the exercise of rights can't live and thrive on anger. It lives and thrives on the dogged pursuit of justice.

If women who value freedom are dragged back into open conflict with oppression, forced to defend ourselves against the reimposition of unjust laws, we will have to call on anger as a weapon again: but we're not at that point yet, and I hope nothing we do now brings us closer to it.

Anger continued on past its usefulness becomes unjust, then dangerous. Nursed for its own sake, valued as an end in itself, it loses its goal. It fuels not positive activism but regression, obsession, vengeance, self-righteousness. Corrosive, it feeds off itself, destroying its host in the process. The racism, misogyny, and counter-rationality of the reactionary right in American politics for the last several years is a frightening exhibition of the destructive force of anger deliberately nourished by hate, encouraged to rule thought, invited to control behavior. I hope our republic survives this orgy of self-indulgent rage.

II. PRIVATE ANGER

I've been talking about what might be called public anger, political anger. But I went on thinking about the subject as a personal experience: getting mad. Being angry. And I find the subject very troubling, because though I want to see myself as a woman of strong feeling but peaceable instincts, I have to realize how often anger fuels my acts and thoughts, how very often I indulge in anger.

I know that anger can't be suppressed indefinitely without crippling or corroding the soul. But I don't know how useful anger is in the long run. Is private anger to be encouraged?

Considered a virtue, given free expression at all times, as we wanted women's anger against injustice to be, what would it do?

Certainly an outburst of anger can cleanse the soul and clear the air. But anger nursed and nourished begins to act like anger suppressed: it begins to poison the air with vengefulness, spitefulness, distrust, breeding grudge and resentment, brooding endlessly over the causes of the grudge, the righteousness of the resentment. A brief, open expression of anger in the right moment, aimed at its true target, is effective—anger is a good weapon. But a weapon is appropriate to, justified only by, a situation of danger. Nothing justifies cowing the family every night with rage at the dinner table, or using a tantrum to settle the argument about what TV channel to watch, or expressing frustration by tailgating and then passing on the right at 80 mph yelling FUCK YOU!

Perhaps the problem is this: when threatened, we pull out our weapon, anger. Then the threat passes or evaporates. But the

weapon is still in our hand. And weapons are seductive, even addictive; they promise to give us strength, security, dominance ...

Looking for positive sources or aspects of my own anger, I recognized one: self-respect. When slighted or patronized, I flare up in fury and attack, right then, right there. I have no guilt about that.

But then so often it turns out to have been a misunderstanding—the disrespect was not intended, or was mere clumsiness perceived as a slight. And even if it was intended, so what?

As my great-aunt Betsy said of a woman who snubbed her, "I pity her poor taste."

Mostly my anger is connected less with self-respect than with negatives: jealousy, hatred, fear.

Fear, in a person of my temperament, is endemic and inevitable, and I can't do much about it except recognize it for what it is and try not to let it rule me entirely. If I'm in an angry mood and aware of it, I can ask myself, So what is it you're afraid of? That gives me a place to look at my anger from. Sometimes it helps get me into clearer air.

Jealousy sticks its nasty yellow-green snout mostly into my life as a writer. I'm jealous of other writers who soar to success on wings of praise, I'm contemptuously angry at them, at the people who praise them—if I don't like their writing. I'd like to kick Ernest Hemingway for faking and posturing when he had the talent to succeed without faking. I snarl at what I see as the unending overestimation of James Joyce. The enshrinement of Philip Roth infuriates me. But all this jealous anger happens only if I don't like what they write. If I like a writer's writing, praise of that writer makes me happy. I can read endless appreciations of Virginia Woolf. A good article about José Saramago makes my

day. So evidently the cause of my anger isn't so much jealousy or envy as, once again, fear. Fear that if Hemingway, Joyce, and Roth really are The Greatest, there's no way I can ever be very good or very highly considered as a writer—because there's no way I am ever going to write anything like what they write or please the readers and critics they please.

The circular silliness of this is self-evident; but my insecurity is incurable. Fortunately, it operates only when I read about writers I dislike, never when I'm actually writing. When I'm at work on a story, nothing could be farther from my mind than anybody else's stories, or status, or success.

Anger's connection with hatred is surely very complicated, and I don't understand it at all, but again fear seems to be involved. If you aren't afraid of someone or something threatening or unpleasant, you can as a rule despise it, ignore it, or even forget it. If you fear it, you have to hate it. I guess hatred uses anger as fuel. I don't know. I don't really like going to this place.

What I am coming away from it with, though, seems to be a pervasive idea that anger is connected with fear.

My fears come down to fear of not being safe (as if anyone is ever safe) and of not being in control (as if I ever was in control). Does the fear of being unsafe and not in control express itself as anger, or does it use anger as a kind of denial of the fear?

One view of clinical depression explains it as sourced in suppressed anger. Anger turned, perhaps, against the self, because fear—fear of being harmed, and fear of doing harm—prevents the anger from turning against the people or circumstances causing it.

If so, no wonder a lot of people are depressed, and no wonder so many of them are women. They are living with an unexploded bomb.

So how do you defuse the bomb, or when and how can you explode it safely, even usefully?

A psychologist once informed my mother that a child should not be punished in anger. To be useful, he said, punishment must be administered calmly, with a clear and rational explanation to the child of the cause of punishment. Never strike a child in anger, he said.

"It sounded so right," my mother said to me. "But then I thought—was he telling me to hit a kid when I'm *not angry*?"

This was shortly after my daughter Caroline, a sweet-natured, affectionate two-year-old, came up to me while the family was sitting around on the terrace outside my parents' house; she smiled up at me rather uncertainly and bit me hard on the leg.

My left arm swung out in full backhand and knocked her away like a fly. She was unhurt, but enormously surprised.

There were then, of course, many tears, many hugs, many consolations. There were no apologies on either side. I only got guilty about hitting her later. "That was terrible," I said to my mother. "I didn't think! I just whacked her!"

My mother then told me about what the psychologist had told her. And she said, "When your brother Clifton was two, he bit me. And he kept doing it. I didn't know what to do. I thought I shouldn't punish him. Finally I just blew up, I slapped him. He was so surprised, like Caroline. I don't think he even cried. And he stopped biting."

If there is a moral to this tale, I don't know what it is.

I see in the lives of people I know how crippling a deep and deeply suppressed anger is. It comes from pain, and it causes pain.

Maybe the prolonged "festival of cruelty" going on in our literature and movies is an attempt to get rid of repressed anger by expressing it, acting it out symbolically. Kick everybody's ass all the time! Torture the torturer! Describe every agony! Blow up everything over and over!

Does this orgy of simulated or "virtual" violence relieve anger, or increase the leaden inward load of fear and pain that causes it? For me, the latter; it makes me sick and scares me. Anger that targets everything and everybody indiscriminately is the futile, infantile, psychotic rage of the man with an automatic rifle shooting preschoolers. I can't see it as a way of life, even pretended life.

You hear the anger in my tone? Anger indulged rouses anger.

Yet anger suppressed breeds anger.

What is the way to use anger to fuel something other than hurt, to direct it away from hatred, vengefulness, self-righteousness, and make it serve creation and compassion?

THE ANNALS OF PARD

An Unfinished Education

LAST THURSDAY NIGHT, Pard woke me up about 3 a.m. by bringing his real, live mouse toy onto the bed so I could play with it too.

This was the third time he's done it, always about 3 in the morning. For the third time (having had some practice) I flung both cat and mouse off the bed with a giant convulsion of bedclothes. Both cat and mouse went right on running briskly about the room, scrabble scrabble silence scutter scamper silence scrabble . . . This time I didn't stick it out at all. I fled down the hall to another bedroom and shut the door.

In the morning Pard was walking up and down the hall all bright and innocent and wondering why I was in that bedroom.

No sign of mouse.

Last time there never was any sign of what became of mouse. I assumed it escaped, that time and this time.

But Friday night Pard woke me about 3 a.m. by rummaging persistently at the base of the standing lamp in my bedroom, making annoying noises, and worrying me that he'd knock the lamp over, even though the base is a big, heavy brass disk. No

way to go back to sleep with that going on. I picked him up and shut him out of the room.

There's no use trying to shut out both Pard and a mouse, because the door is so high off the floor that the mouse can run back in, leaving Pard out, and then Pard will rattle the door and cry.

But this time when I shut him out, Pard just went down the hall to sleep in the other bedroom. This told me, indirectly, something about the mouse.

Pard is an excellent hunter, but as I said in an earlier blog, he doesn't know that he should kill the prey, nor, evidently, does he know how to. His instincts and skills are impeccably feline, but his education was incomplete.

Saturday morning, once I was up, dressed, and more or less competent, I lifted the heavy lamp base and looked under it. Sure enough, the poor little dead mouse was there. In its last refuge. Injury, terror, exhaustion. All can be mortal.

I wrote a poem for the mouse. I am not sure it's finished yet, I keep moving lines and changing bits of it, but here it is in its current form.

> *Words for the Dead*
>
> Mouse my cat killed
> gray scrap in a dustpan
> carried to the trash
> To your soul I say:
> With none to hide from
> run now, dance
> inside the walls
> of the great house

And to your body:
Inside the body
of the great earth
in unbounded being
be still

An Unfinished Education, Continued

January 2016

WE WERE READING Penelope Fitzgerald's *The Beginning of Spring* aloud before dinner last night when Pard came trotting through the living room in an uncharacteristically feral way: body low to the ground, tail down, head poised, eyes all black pupil. And sure enough, a small mouse in his mouth. He put it down, let it go, recaught it, and trotted on back to the kitchen, the tiny black tail hanging out of his mouth. We went on grimly with Penelope. After a while Pard came back, mouseless, and looking clueless. He wandered off, and we decided, or hoped, he'd lost the mouse.

Just as we were about to do the dishes he reappeared with it. It was now distinctly less active, but still alive. Pard was confused, troubled, and purposeless, as he always is when he has caught a mouse: totally possessed by the instinctive command to hunt, to catch, to bring the catch to the family as trophy or toy or food, but lacking any instinct or instruction as to how to follow through to the kill.

A cat with a mouse — the cliché example of cruelty. I want to say clearly that I do not believe any animal is capable of be-

ing cruel. Cruelty implies consciousness of another's pain and the intent to cause it. Cruelty is a human specialty, which human beings continue to practice, and perfect, and institutionalize, though we seldom boast about it. We prefer to disown it, calling it "inhumanity," ascribing it to animals. We don't want to admit the innocence of the animals, which reveals our guilt.

It's possible that I could have caught the mouse and taken it outside to spare it some suffering. (Charles couldn't, because after an operation a little while ago he's forbidden to stoop down.) I didn't even try. To do it, I'd have to be highly motivated, and I'm not. I feel neither guilty nor ashamed of that, only unhappy about the whole situation.

I've never been able to come between a cat and its prey. When I was twelve or so our tomcat caught a sparrow on the lawn. Two of my brothers and my father were there. All three shouted at the cat, tried to get the bird away from it, and succeeded, in a cloud of feathers and confusion. I recall clearly, because I was clearly aware of my own feelings at the time, my refusal to join the shouting and scolding and scrambling. I disapproved. I thought the matter was between the bird and the cat and we had no business interfering with it. This may appear very cold-blooded, and perhaps it is. There are certain other matters of life and death toward which I have a similarly instant, absolute, imperative response — it is right to do this, or it is wrong to do this — which is not affected by personal preference or tenderness, has nothing to do with the reasonings of conscience, and cannot be justified by the arguments of ordinary morality. But neither can it be shaken by them.

Our feeble solution to Pard and the mouse's problem was to shut them into the kitchen, leaving them to work it out in their own way. (And the dishes to be done in the morning.) What the

mouse needed was to find the hole he'd come in by. Pard's box is in the kitchen porch and his water bowl on the kitchen floor, so Pard had all he needed. Plus his problem.

And minus us. He is a very human-dependent cat. He's almost always unobtrusively nearby. Fits of flying about at eye level, wreaking sudden havoc on bedspreads, galloping madly up flights of stairs, and bouncing backward stiff-legged and humpbacked with enormous tail and glaring eyes down the hall ahead of you for no reason occur now and then, but mostly he's just quietly somewhere near one or the other of us. Keeping an eye on us, or sleeping. (Right now he's conked out on his beloved Moebius scarf right next to the Time Machine, about eighteen inches from my right elbow.) Nights he almost always spends on my bed around the vicinity of my knees.

So I knew I'd miss him last night and he'd miss me. And we did. I got up to pee at around 2 a.m. and could just hear him weeping softly down in the kitchen. All the way home from the Humane Society in the carrier, he meowed and yowled lustily, but since then he's never raised his voice. Even when shut by mistake in the basement, he just stands at the door and cries, softly, *Meew?* till somebody happens to hear him.

I steeled my heart, went back to bed, and felt bad till 3:30.

In the morning getting dressed I heard *Meew?* again, so I dressed fast, hurried down, and opened the kitchen door. There was Pard, still puzzled, still anxious, but tail in the air to greet me and breakfast.

There was no mouse.

These chapters of the saga almost always end now in mystery. An unhappy mystery.

A result, maybe, of the only partly worked-out relationship between two immensely different ways of being, the human and

the feline. Wild cat and wild mouse have a clear, highly developed, well-understood connection—predator and prey. But Pard's and his ancestors' relationship with human beings has interfered with his instincts, confusing that fierce clarity, half taming it, leaving him and his prey in an unsatisfactory, unhappy place.

People and dogs have been shaping each other's character and behavior for thirty thousand years. People and cats have been working at transforming each other for only a tenth that long. We're still in the early stages. Maybe that's why it's so interesting.

Oh, but I forgot the weird part! After I'd hurried downstairs this morning, as I got to the kitchen door, I saw a triangle of white on the floor under it, a piece of paper. A message had been shoved under the door.

I stood and stared at it.

Was it going to say "Please let me out" in Cat?

I picked it up and saw a friend's telephone number scribbled in pencil. The scrap of paper had fallen off the telephone table in the kitchen hall. Pard was still saying *Meew?* very politely behind the door. So I opened it. And we had our reunion.

Doggerel for My Cat

His paws are white, his ears are black.
When he isn't around I feel the lack.
His purr is loud, his fur is soft.
He always carries his tail aloft.
His gait is easy, his gaze intense.
He wears a tuxedo to all events.
His toes are prickly, his nose is pink.
I like to watch him sit and think.
His breed is Alley, his name is Pard.
Life without him would be hard.

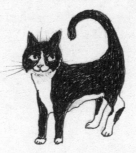

Part Four

REWARDS

The Circling Stars, the Sea Surrounding: Philip Glass and John Luther Adams

April 2014

EVERY YEAR ONE of the Portland Opera Company's productions is sung by the singers in the company's outstanding training program. In 2012 it was Philip Glass's short opera *Galileo Galilei*. There is a splendor to young voices different from the patina of the experienced singer; and these performances always have an extra charge of tension and excitement.

The bold, beautiful, intricately simple set, all circles and arcs and moving lights on different planes, was, I believe, from the Chicago premiere in 2002; the conductor was Anne Manson.

The first scene shows us Galileo old, blind, and alone. From there the story follows a reverse spiral through time, revolving back lightly and ceaselessly through his trial, his triumphs, his discoveries, to the last scene, where a little boy named Galileo sits hearing an opera about Orion and the Dawn and the circling planets written by his father, Vincenzo Galilei. It is all

borne along and buoyed up by the endlessly repetitive and ever-changing music, always spiraling, never resting, and yet moving with the slow majesty of the great orbits, without reference to any beginning or ending, in a vast, joyous continuity. It moves, it moves, it moves . . . *E pur si muove!*

I was rapt from the first moments, and by the last scene I could scarcely see the stage for tears of delight.

We went back the next night and had the same radiant experience. There's now a recording of the Portland Opera performance (Orange Mountain Music, OMM 10091). I have listened to this with deep pleasure and will listen to it again. But I am still certain that the true power of opera, and certainly this opera, is in the actual production, the immediate, live presence of the singers and the interaction of their voices and the music with the sets, lighting, action, movements, costumes, and audience to create a global, irreproducible experience. This is how all the great opera composers have understood their undertaking. Recording, film, all our wonderful instruments of virtuality, catch only the shadow, recall only a memory of that lived experience, that moment of real time.

An opera is a preposterous proposition. It's almost incredible that any production of any opera ever comes off. To a lot of people, of course, it doesn't — Tolstoy was one. Philip Glass's music is also somewhat preposterous. To a lot of people it isn't music at all. Some of his pieces sound mechanical, even perfunctory to me; but having been deeply moved years ago by the film *Koyaanisqatsi*, and by his Gandhi opera *Satyagraha* on stage in Seattle, I'm always ready to hear what Glass is up to now. For *Galileo* he had a brilliant librettist, Mary Zimmerman, and rose to the challenge. The words and action of the piece are luminously in-

telligent: they go to the heart of what Galileo's life and thought mean to us in terms of knowledge, courage, and integrity both scientific and religious, yet they linger also on the humanity of the man who rejoiced in his daughter, rejoiced in thought and argument, rejoiced in his work and his great discoveries, and for his public reward got shame, silence, and exile. It is a grand story, and a dark one: quite right for opera.

I found *Galileo* completely beautiful. I think it as beautiful in its way as Gluck's *Orfeo* is in its. Neither is so dramatically and emotionally huge as much nineteenth-century opera, but both are complete, whole, every element in them entering into a ravishing totality. *Galileo* has an intellectual grandeur rare in opera, but even that is in the service of making pleasure, true pleasure — the pleasure given by something noble, thoughtful, deeply moving, and delightful.

And this was my first twenty-first-century opera. What a marvelous start!

Just two years later, this March, the Seattle Symphony brought a concert to Portland that included a piece, *Become Ocean*, they commissioned (and bravo for doing so!) from the composer John Luther Adams.

There are too many composers named John Adams. The one from San Francisco is better known at present, but I've found his music increasingly disappointing ever since the curiously brainless and vapid opera *Nixon in China*. Living in Alaska, John Luther Adams is still marginal not only to mainland America but to mainstream fame. But I believe that will change as his music is heard.

For *Become Ocean*, the orchestra is divided on stage into three groups with differing instrumentations. All three play continuously, each following its own pattern of tempo, volume, and tonality. Now one group and now another dominates, the ebb and flow of each interpenetrating with the others like currents in the sea. Sometimes they all are on the ebb; again their crescendos overlap until a vast, deep tsunami of music swells over the hearers, overwhelming . . . and then subsides again. The harmonies are complex, there are no tunes as such, but there is no moment in the work that is anything less than beautiful. The hearer can surrender to the surrounding sound as a ship surrenders itself to the waves, as the great kelp forests surrender to the movement of the currents and the tides, as the sea itself surrenders to the gravity of the moon. When the deep music ebbed away at last, I felt that I'd come as near as ever I will to indeed becoming ocean.

We stood up to applaud, but not many people did. Portland audiences tend to leap to their feet automatically for a soloist, but rise more selectively for mere orchestra. I think the response was to some extent puzzled, maybe bored. *Become Ocean* is forty-five minutes long. A man near us was growling about it never ending, while I was wishing it never had.

Edgard Varèse's *Déserts* came next in the program, a piece that skillfully and faithfully obeys the modernist mandates of discord. Maybe we have at last worked through the period when serious music had to seek antiharmony and strive to shock the ear. Neither Glass nor Adams appears to be following a program dictated by theory; like Gluck or Beethoven, they're innovative because they have something new to say and know how to say it. They are obedient only to their own certainties.

I came away from both these concerts marveling that while our republic tears itself apart and our species frantically hurries to destroy its own household, yet we go on building with vibrations in the air, in the spirit — making this music, this intangible, beautiful, generous thing.

Rehearsal

April 2013

SITTING IN ON a rehearsal is a strange experience for the author of the book the play is based on. Words you heard in your mind's ear forty years ago in a small attic room in the silence of the night are suddenly said aloud by living voices in a bright-lit, chaotic studio. People you thought you'd made up, invented, imagined, are there, not imaginary at all—solid, living, breathing. And they speak to each other. Not to you. Not anymore.

What exists now is the reality those people build up between them, the stage-reality that is as ungraspable and fleeting as all experience, but more charged than most experience with intense presence, with passion . . . until suddenly it's over. The scene changes. The play ends.

Or in a rehearsal, the director says, "That was great. Let's just take it again from where Genly comes in."

And they do: the reality that vanished appears again, they build it up between them, the doubts, the trust, the misunderstanding, the passion, the pain . . .

Actors are magicians.

All stage people are magicians, the whole crew, on stage and

behind it, working the lights and painting the set and all the rest. They collaborate methodically (ritual must be methodical, because it must be complete) in working magic. And they can do it with remarkably unlikely stuff. No cloaks, no magic wands or eyes of newt or bubbling alembics.

Essentially they do it by limiting space, and moving and speaking within that space to establish and maintain a Secondary Creation.

Watching a rehearsal makes that especially clear. At this point, some weeks before first night, the actors wear jeans and T-shirts. Their ritual space is marked out with strips and bits of tape on the floor. No set; their only props are a couple of ratty benches and plastic bowls. Harsh lights glare steadily down on them. Five feet away from them, people are moving around quietly, eating salad out of a plastic tub, checking a computer screen, scribbling notes. But there, in that limited space, the magic is being worked. It takes place. There another world comes into being. Its name is Winter, or Gethen.

And look! The king is pregnant.

Someone Named Delores

October 2010

A SENTENCE IN a story has been troubling me. The story, by
Zadie Smith, was in *The New Yorker* of October 11. It's in the first
person, but I don't know whether it's fiction or memoir. Many
people don't even make the distinction, now that memoir takes
the liberties of fiction without taking the imaginative risks, and
fiction claims the authority of history without assuming the fac-
tual responsibilities. To my mind the I of a memoir or "personal
essay" is a very different matter from the I of a story or novel,
but I don't know if Zadie Smith sees it that way. And so I don't
know whether she's speaking as a character in fiction or as her-
self when toward the end of her tale of a seemingly unrepaid loan
to a friend she says, "The first check came quickly but sat in a pile
of unopened mail because these days I hire someone to do that."

The implacable editor in my hindbrain promptly inquired
You hire someone not to open the mail? I silenced the meddling rep-
tile, but the sentence continued to bother me. "These days I hire
someone to do that." What's wrong with that? Well, I guess it's
the "someone." Someone is no one. The nameless nobody hired
to answer the mail of a somebody with a name.

So at this point I'm beginning to hope that the story is fiction and thus that the narrator is not Zadie Smith, because this doesn't sound like the voice of a writer highly sensitive to class and color prejudices. It reminded me, in fact, of the dean's wife, when I was a lowly assistant professor's wife, who couldn't leave "my housekeeper" out of her conversation for five minutes, she was in such a state of admiration of herself for having the grand house that required keeping and the housekeeper to keep it. But that was silly, naive, like Mr. Collins continually mentioning "my patron Lady Catherine de Bourgh." The statement "these days I hire someone to do that" has a harsher ring to it.

And so what? Why shouldn't a highly successful writer hire help and say so? And what skin is it off my nose?

Envy, of course, in the first place. I am envious of people who hire a servant with perfect assurance of righteousness. I envy self-confidence even as I dislike it. Envy coexists only too easily with righteous disapproval. Indeed perhaps the two nasty creatures live off each other.

And then, annoyance. There's an "of course" implied in "I hire someone to do that," and there's no "of course" about it. But people think there is, and this kind of talk encourages them to think so—which annoys me.

It's a widespread illusion: a writer (a successful writer, a real writer) doesn't do her own mail. She has a secretary to do it, as well as helpers, amanuenses, researchers, handlers—lord knows what—maybe an editor's hole in the east wing, like the priest's hole in old British houses.

I imagine writers commonly had secretaries a century ago. Henry James did, sure enough. But Henry James was not exactly your average writer, right?

Virginia Woolf didn't.

Among writers I know personally, only one has a secretary to do mail. To me it seems a perquisite of the extremely successful, and of a magnitude of success that daunts me. Privacy to be with my family and do my work was of the first importance to me. So when I began to need help answering my letters, I found it extremely difficult to convince myself that I needed it badly enough to justify my hiring "someone," bringing a stranger into my study, setting myself up as a boss.

I always had trouble calling Delores my secretary, it sounded so pompous (echoes of "my housekeeper . . ."). If I had to speak of her to strangers I said her name, or "my friend who does mail for me." But I knew that this latter phrase was one of the mildly devious devices by which we handle guilt, the ways we try to reintroduce humanity into the relationship of hirer and hired, which inevitably, to whatever slight a degree, involves inequality, the raising up of one and degradation of the other. Democracy, by strenuously denying the fact of inequality, does enable us, to a surprising extent, to act as if it didn't exist; but it does exist, and we know it. So our job is to keep the inequity of power as small as possible, and refuse to let our common humanity be reduced, however slightly, even by a careless word, by an assertion of unequal worth. My envy of writers who hire a person to handle their mail and annoyance at people who assume that I have such help are really quite mild, but they are painful now, because I did have "someone," but I have lost her.

Delores Rooney, later Delores Pander, was my helper and dear friend.

Thirty years ago or so, I finally got up my courage and asked around for a professionally competent and discreet person to give me a hand with my letters, which were getting beyond me. Our mutual friend Martha West; who had worked with Delo-

res as a secretary in an office, recommended her. She was then working as manager-agent for a dance company. We rather nervously gave it a try.

I had never dictated anything to anybody (outside Beginning French courses, where you very slowly and clearly read a *dictée* in French to the students, who very slowly and inaccurately write it down). Delores had taught herself shorthand and was a whiz at it—a skill now, I suppose, almost entirely lost—and she'd taken lots of dictation from lots of dictators. She coached me in composing a letter orally, and encouraged me with praise; she was an excellent teacher. And also she'd worked and lived with artists, painters, dancers, and was used to artistic temperamental peculiarities, having a few of her own.

We got to doing letters quickly and easily, and I soon began to draw on her as a collaborator in composing the letters—what to say and how to say it. *Does that sound all right?—What if you said this instead of that?—What on earth am I going to write to the man who sent me the 600-page manuscript about fairies on Venus?—This one's a whiner, you don't have to answer him . . .* Delores was always better than me at kind answers to kooks, but she was tough-minded too, and encouraged me not to answer a letter that was troublingly weird or made unreasonable demands. She got to be so good at replying to the eternally repeated questions that I could hand her a letter and just say "idea for Catwings" and the true tale of how I happened to think of cats with wings was all ready in her computer—though she varied it slightly according to her mood and the age of the inquirer. She had a gracious, graceful tone in discouraging problematic requests by explaining why I couldn't personally reply just now. She covered for me beautifully. She loved to answer children's letters, even when they were the mechanical kind some teachers make kids write. The open

kindness and generosity of her spirit lent all my correspondence
a quality it would never have had without her collaboration.

She never came more than once a week, usually only once
every three or four weeks. I'd do the most urgent business cor-
respondence and let the rest and the fan mail pile up. She got a
computer before I did, and it eased her work a great deal. When
I got one, it didn't make much difference at first. But when email
really got going I began to be able to deal with all the real busi-
ness myself. Still Delores and I together handled nonurgent busi-
ness, the fan letters from readers, and what we called the Gim-
mies: the letters everybody who becomes visible to the public
gets, asking you to do this, give to that, endorse this book, speak
at that good cause, etc. Even if you can't possibly say yes to them,
most such letters are well intentioned and deserve a civil no.
Delores said no thank you in every possible way, always politely.
It was a great burden off me. She said that the Gimmies were
boring but just various enough to be entertaining too.

As for fan mail, letters from readers have always come to me
on paper only, my crude but effective way of keeping the volume
down. The letters people write me—often with pen and ink, or
in pencil, crayon, glitter, and other media if they're children—
are ever amazing, giving me immense pleasure and reward, but
they are also never-ending. I knew there was no way I could han-
dle the load if I tried to read and answer them on my website or
on email. But I have always felt that such letters deserve a reply,
however brief, and for years Delores was my invaluable aide in
answering them.

We loved each other as friends, but didn't have extensive
contact outside our work sessions. She was a busy woman: she
soon became the writer Jean Auel's secretary four days a week,
and was agent and manager for her husband, the painter Henk

Pander; when her parents grew old and sick she looked after them, and late in life she adopted and brought up her granddaughter. Our friendship was expressed mostly during and in our working relationship. I always looked forward to Delores coming, and we always spent half the time talking, catching up. Once, when I was scared by a stalker, she and Henk gave me wonderful immediate support.

As the years went on she seemed to grow shyer and more withdrawn from her friends than she had been, I do not know why. She told me once that she liked coming to work with me because we laughed together.

Her computer began to get out of date, and her life was complicated by various issues; her energy was being overtried. She couldn't or didn't want to figure out how to help me with e-correspondence the way she did with paper mail, which she took home along with dictated answers or suggested notes from me. So I came to do all the email and most of the letters, leaving her only some Gimmies and no-thank-yous and those fan letters that needed only acknowledgment.

Delores's joy in life had been visibly flagging for a long time when she was diagnosed, last year, with cancer. At first it seemed local and curable, but proved to be metastasizing. It killed her in a few months. There was a brief and lovely respite or remission for a few weeks late in her illness, when we were able to visit with her quite often, and laughed together as we had used to laugh. Then the cruel disease closed in again. She died a few months ago, attended with great tenderness by her husband.

I find it extremely hard to talk about people I loved who have died. I can't now make a proper tribute to that complex and beautiful woman, or say more than that I miss her friendship in every way.

Without her, I've had to give up the effort to answer fan mail, at least temporarily. As for the Gimmies, some of them get answered, some of them don't. I suppose I could hire someone to do that.

But I doubt that I will. I can't put my heart into it.

Without Egg

July 2011

VISITING VIENNA IN the early 1950s, Charles and I stayed in style for very little expense at the old König von Ungarn Hotel, which had been there since at least the 1820s. We ate breakfast at a café around the corner. Always the same café and the same breakfast: good coffee, fresh fruit, crisp rolls with butter and jam, and a soft-boiled egg. Perfect. Invariable. Every morning.

I don't know why I got it in my head one morning to vary it, but I did, and when the tall, middle-aged waiter arrived in his impeccable dark coat, I indicated that I wanted the usual breakfast, without the egg.

He appeared not to understand, which, given the quality of my German, was understandable. I repeated something like "Kein Ei," or "Ohne Ei."

He responded slowly, in a shaken voice, "Ohne Ei?"

He was disturbed. I was ruthless. Yes, I said, without egg.

He stood for quite a while silent, trying to handle the shock. He visibly forced himself not to appeal, or plead, or show his disapproval. He was a waiter, a disciplined, skillful Viennese waiter, and must obey the most perverse customer. "Without egg, ma-

dame," he said softly, almost unreproachfully, and went away to fetch my eggless breakfast, which he brought and set before me with silent, funereal dignity.

We still laugh recalling that tiny incident of nearly sixty years ago, but it is also kept alive in my memory by a sense of guilt. For one thing, in 1954, in Vienna, an egg meant something. The city was just coming out of very bad times. It was still occupied, divided among the U.S., the British, and the Russian armies; the cathedral had rearisen and the opera house was rearising from the rubble of bombing, but damage and destruction was everywhere, and the effect of privation plain to see in the faces and bodies of people on the street. An offer of food in a city that has gone hungry is not a small matter.

Also, I willfully and needlessly disturbed the order of that waiter's universe. A very small universe, the Viennese café breakfast, but a stable, orderly, perfected one. Better not change something that has achieved excellence. And it was unkind to demand of a person who spent his working life maintaining that excellence to impair it, to do something he so clearly felt was wrong. After all, I could have let him bring the egg and simply not eaten it. He was far too good at his job to have taken notice, except possibly for a mild, commiserative "Madame doesn't feel hungry this morning?" To have an egg and not to eat it was my privilege. To refuse to let him bring the egg was to interfere with his privilege, which was to bring me a complete and proper Viennese café breakfast. I still want to laugh when I think about it, and I still feel a twinge of guilt.

The guilt has increased since I began, a couple of years ago, to have a soft-boiled egg for breakfast—to have, in fact, a Viennese café breakfast—every morning. Invariably.

I can't get those lovely, light, crisp European rolls. (Why do

the artisanal bread people in this country think crust should be thick and tough? The more leathery, the more artisanal?) But Thomas's English muffins are very good, so I have them, with tea, fruit, and a three-and-a-half-minute egg eaten, as in Vienna, from the shell.

To soft-boil an egg I put it in a small pot with cold water to cover, set it on high heat till it boils furiously, take it off at once, turn over the egg timer (a three-and-a-half-minute glass), and start the muffins toasting. When the sand is through the glass, the egg comes out of the water and into the egg cup.

As you see, a certain care and ceremony is involved, which is what I wanted to talk about, and also why the egg cup is important.

If you crack a soft-boiled egg and dump it out into a bowl, it tastes the same but isn't the same. It's too easy. It's dull. It might as well have been poached. The point of a soft-boiled egg is the difficulty of eating it, the attention it requires, the ceremony.

So you put your freshly boiled egg into the egg cup. But not everybody is familiar with egg cups.

In this country they are usually an hourglass shape, with one lobe or bowl bigger than the other. The small end is just big enough to hold the egg. You could eat it there from its shell, but most Americans take it out, turn the egg cup over, crack the egg, and dump it into the larger bowl, where they smoosh it around and eat it.

British and European egg cups don't offer that option; they have no big bowl; they are just a small china cup on a short pedestal, like a goblet, in which the egg sits upright. You have no choice but to eat your egg out of its own shell. This is where things get ceremonial and interesting.

So you put your freshly boiled egg into the egg cup—but

which end up? Eggs are not perfect ovoids, they have a smaller end and a bigger end. People have opinions about which end should be up, i.e., which end you're going to actually eat the egg out of. This difference of opinion can become so passionate that a war may be fought about it, as we know from Jonathan Swift. It makes just as much sense as most wars and most differences of opinion.

I am a Big-Ender. My opinion, which I will defend to the death, is that if the big end is up it's easier to get the spoon into the opening created when you knock off the top of the egg with a single, decisive whack of your knife blade. Or possibly — another weighty decision, another matter of opinion, with advocates and enemies, the Righteous and the Unrighteous — you lift the top of the egg off carefully from the egg-encircling crack you have made by tapping the shell with the knife blade all the way round about a half-inch down from the summit.

Some mornings I whack. Some mornings I tap. I have no opinion on the matter. It depends on my mood.

Some elements of the ceremony offer no choice. The knife has be steel, since the sulfur in eggs blackens silver, and the egg spoon must also be untarnishable — stainless steel, or horn. I've never seen a gold egg spoon, but I'm sure it would do. Whatever the material, the spoon has to have a small bowl with a fine edge on it: a thick edge can't coax all the egg white off the inside of the shell. The handle is short, for good balance and easy handling. An egg spoon is a tiny implement that, like the Viennese breakfast, cannot be improved. Like all good tools, it gives pleasure by its pure aptness. It does one thing only, but does it perfectly, and nothing else can do it. Trying to eat an egg from the shell with a normal spoon is like mending a wristwatch with a hammer.

The sole imperfection of the egg spoon is that it's so small it

gets lost. Horn spoons are larger, but the beautiful horn spoon my daughter gave me finally wore out, its edge becoming coarse and fibrous. Replacement can be a problem; most Americans don't eat their eggs from the shell, and the implement has become rare and hard to find. When I see one, I acquire it. My current egg spoon is stainless steel; on the handle are the letters *K L M.* I will not go into how we came to own this spoon.

You see what I mean about difficulty. Eating an egg from the shell takes not only practice but resolution, even courage, possibly willingness to commit crime.

If you are in the whacking mood, the first whack of the knife on the shell is decisive. A firm whack on a good shell in the right place decapitates the egg cleanly with one blow — ideal. But some eggshells are feeble and crumbly, and sometimes your aim is tentative or faulty (after all, this is something you have to do before breakfast). If you hit too high, the opening isn't big enough; too low, you get into yolk, which you don't want to do yet. So maybe you choose to tap instead of whacking — nowhere near as exciting, but you have more control of the outcome.

So now you have opened your egg. You stick the spoon right down into it, but not too suddenly, or the yolk will well up and dribble wastefully down the outside of the shell. The three-and-a-half-minute egg white is barely firm, while the yolk has thickened just enough to make a beautiful golden sauce for the white. Your job is to mix the two nicely so you get a balance of yolk and white in each small spoonful, while not destroying the delicate little bowl you're eating from, the eggshell. This takes attention.

The more complete the attention, the more you actually *taste the egg.*

It may be apparent by now that this whole blog is a sub-

tle blow against double-tasking, and a paean to doing one single thing with, as the Bible puts it, "all thy might; for there is no work, nor device, nor knowledge, nor wisdom, in the grave, whither thou goest."

Nor is there any breakfast there. The grave is without egg.

The flavor of a fresh soft-boiled egg is extremely subtle. I like salt and pepper on a fried egg but nothing at all on a boiled egg. It is completely satisfactory in and by itself. If a little butter from the muffin gets into it, that's fine too.

The soft-boiled-egg experience is the same every morning and never the same. It remains endlessly interesting. It is invariably delicious. It delivers a small, solid dose of high-quality protein. Who could ask for more?

Of course, I'm very lucky: I can get toxin-free eggs at our co-op from local farmers who don't cage their birds in pestholes and don't feed them on carrion. The eggs are brown, with strong shells and orange yolks, not the weak, pallid things laid by hens kept in filth and torment all their lives. The Oregon Legislature has at last decided to ban poultry batteries, hurray—the ban to take effect in 2024, unhurray. The lobbies who run our lives demand that torture, ordure, and disease continue for thirteen more years. I will not live to see the birds go free.

Nôtre-Dame de la Faim

October 2011

I VISITED A great cathedral this week. It's situated in a mixed industrial/small business/residential area not far from the Portland Airport, an odd place for a cathedral. But it has a huge congregation and is full of people, not just on Sundays but every day of the week.

And it's big. Nôtre-Dame de Paris covers about 67,000 square feet. This one is nearly twice as big, 108,000 square feet, two full city blocks (and its overflow, adjunct building across the river covers 94,000 square feet).

Nôtre-Dame, with its towers, is much taller, and is built of stone all carved with saints and gargoyles, and is endearingly ancient and beautiful. This one looks rather unimpressive as you approach it, partly because there are buildings near it and you can't really get a view of it, and partly because it wasn't built long ago to celebrate and embody spiritual worship, but recently, in dire need, for a specific material purpose. Still, I wouldn't discount a very large element of the spirit in the building of it.

From the outside it looks like a particularly huge warehouse, but it hasn't the strangely menacing, fortresslike look of the great windowless citadels of consumerism, Walmart and the rest. When you get inside, you see the cathedral. The high, airy entrance hall leads you first, on an elegantly stone-tiled floor with little bronze decorations set in here and there, to an area of offices and cubicles. Most churches hide their administrative department, but this one puts it right out front. The walls are blond wood, everything is spacious and handsome. Like the high nave of Nôtre-Dame, the startlingly high steel-braced wooden ceiling soars above all the small human activity down on the floor beneath. In the old cathedral that height creates a great, mysterious, upper space of shadows. But the space beneath this vault is luminous.

It wasn't till I entered the interior, the cathedral proper, that I understood why they'd built the ceiling so high. As there should be, there are great doors to open into the sacred space. And as a sacred space will do, the first sight took my breath away. I stood silent. I remembered what the word *awe* means.

Much of the interior of the huge building is visible from that doorway, or would be except that the whole floor is covered with immense, towering blocks and piles and stacks of crates, cartons, boxes, and containers, arranged in gigantically severe order, with wide aisles between each tower or bay. Only down the aisles can you see the far walls in the far distance. There are no permanent walls or divisions. The immense, splendidly cantilevered ceiling stretches serenely above it all. The air is cool, fresh, and clean, with the faintest smell of garden stuff, fresh vegetables. Vehicles run quietly up and down the aisles, miniforklifts and the like, looking quite tiny among the high blocks

and stacks, constantly busy at moving crates and boxes, bringing in and taking out.

Well, it isn't a cathedral. That was a metaphor. It's just a warehouse, after all.

But what kind of warehouse stores nothing to sell? Nothing, not one item in all these (literally) acres of goods, is or ever will be for sale.

Actually, it's a bank. But not the kind of bank where money is the only thing that happens.

Here is where money doesn't happen.

This is the Oregon Food Bank. Every box in the great cubical stacks between the aisles, every carton, every can, every bottle, every crate, holds food. Every carton, every can, every pound, every ounce of that food will be given to the people of Oregon who haven't the money to buy what they need to live on.

It *is* a cathedral, after all. The cathedral of hunger.

Or should I say the cathedral of generosity? Of compassion, or community, or caritas? It comes to the same thing.

There are people who need help.

There are people who deny it, saying that God helps those who help themselves and the poor and the unemployed are merely shiftless slackers sponging on a nanny government.

There are people who don't deny poverty, but they don't want to know about it because it's all so terrible and what can you do?

And then there are people who help.

This place is the most impressive proof of their existence

I ever saw. Their existence, their efficiency, their influence. This place embodies human kindness.

In, of course, the most unspiritual, lowly, humdrum, even gross way. In a thousand cans of green beans, in towers of macaroni boxes, in crates of fresh-picked vegetables, in cold side-chapel refrigerators of meat and cheese . . . In hundreds of cartons with improbable names of obscure beers on them, donated by the brewers because beer cartons are particularly sturdy and useful for packing food . . . In the men and women, employees and trained volunteers, operating the machinery, manning the desks, sorting and packaging the fresh produce, teaching survival skills in the Food Bank classrooms, kitchens, and gardens, driving the trucks that bring food in and the trucks that take food out to where it's needed.

For these towering walls and blocks and reefs of goods — twelve to eighteen thousand pounds of food in each bay of the warehouse — will vanish, melt away like sandcastles, tonight or in a few days, to be replaced instantly by the supply of boxed, canned, glassed, fresh, and frozen food, which in turn will melt away in a day or a week, going where it's needed.

And that's everywhere. The Food Bank distributes in every county of the state of Oregon plus one county of Washington State. They don't have to look far to find people who need help getting enough to eat.

Anywhere kids are, to start with. Many school-age children in our country, towns, and cities don't get three meals a day, or even two. Many aren't always sure if they'll get anything to eat today at all.

How many? About a third of them. One child in three.

Put it this way: If you or I were a statistic-parent with three

statistic-kids in school, one of our three children would be hungry. Malnourished. Hungry in the morning, hungry at night. The kind of hungry that makes a child feel cold all the time. Makes a child stupid. Makes a child sick.

Which one of our children . . . which child . . . ?

The Tree

January 2011

WE TOOK DOWN the Christmas tree this morning. It was a very pretty little fir, three and a half or four feet tall, a tabletop tree, said the woman at the florist's next to Trader Joe's, where we bought it. We put it on a wooden box in the corner window of the living room, as I believe a Christmas tree should be seen from outside and also should be able to see outside. To be exact, I don't think a tree can see, but it may be aware of light and darkness, of insideness and outsideness. In any case it looks right with the sky over it or through its branches. Before we decorated it, it stood there, sturdy, plain dark green, a complicated higher organism, a very definite presence in the room. When we had an artificial tree, its nonentity made me realize what I feel about a living tree, not only the splendid, big, tall Christmas trees we used to have when I was a child and when my children were children, but a little one too—that it is as much a presence in a room as a person or an animal. An unmoving presence that says nothing, but is there. A very taciturn visitor from Norway, perhaps. Speaking no English, entirely undemanding, wanting nothing but a drink of water every few days. Restful. A pleasure to look

at. Holding darkness in it, a forest darkness, in the green arms held out so calmly, steadily, without effort.

Our Norwegian visitor leaned out into the room a little— we couldn't get it quite vertical with the screw pins in the base —but nobody could see it from the side anyhow, as it stood between the writing desk and the bookcase, so we didn't worry. It was beautifully symmetrical without having had half its branch tips sheared off with a hedge trimmer, as lot trees so often have. It certainly was a lot tree. It had never been in the forest I saw in it. It had grown on some slope not far from Mount Hood, probably, along with hundreds or thousands of other young firs in straight rows, one of the dreariest sights in our farmlands, almost as soul-blighting as a clear-cut. It is often a sign of the small farmer giving up crop-growing, crowded out by agribusiness, or the nonfarmer putting in a tree lot as a tax write-off. Our tree had not known forest. It was a forest tree all the same. And it had known rain, sun, ice, storm, all the weathers, all the winds, and no doubt a few birds, in its day. And the stars, in its night.

We put the lights on the tree. We put the old golden bird with the ratty tail on top. The small gold glass snail-shell ornaments we bought for our two-foot tree in Paris in '54, a dozen of them and a dozen gold glass walnuts—one walnut left, and nine snails, one with a hole in its tissue-fragile shell—go on the top branches, because they are small and weigh nothing and you can see them there. The bigger glass balls, some of which are so old they are crazed and translucent, go lower down; the bigger they are the lower they go, it is a rule of life. The little beasts, tigers and lions and cats and elephants, dangle on loops from the branches; the little birds sit up on them, clutching with unsteady wire claws. Now and then a bird loses its grip and is found upside down under its branch and has to be reseated.

The tree looks very nice, a proper Christmas tree, except the LED lights are really much, much too bright for it. They are small but violent. Old-fashioned frosted lights, too big for this tree, would suit it better, with their soft, diffuse glow which you could hide among the branches. And some of the colors of the LEDs are terrible; a screaming magenta is the worst. What has magenta to do with Christmas, or anything else? I'd take off all the magentas and airport-landing-strip blues and have it green red and gold, if I could, but the strings come with five colors, and they don't seem to sell replacement lights, you have to buy a whole new string, which will, of course, have the same five colors. I made little tubes of tissue paper and slipped them over the small, fiercely glaring bulbs, but it didn't make much difference, and it looked kind of crummy. All the same I left them on.

So Christmas came, and the tree shone each day and each night until I unplugged it before going to bed. I know you don't really have to turn the lights off, LEDs burn so cool, but safety is safety, and habit is habit, and anyhow it seems wrong not to let a tree have darkness. Sometimes after I unplugged it I stood with it and looked at it, silent and dark in the dark room, lit only by the glow of the small electric candle behind it that illuminates the sign in the window that says PEACE. The candle cast faint, complicated shadows up on the ceiling through the branches and needles. The tree smelled lovely in the dark.

So Christmas went, and the New Year came, and on the day after New Year's Day I said we ought to take the tree down, so we did. I wanted to keep it one more day after we took the lights and ornaments off. I liked the tree so much without any decorations. I didn't want to lose that quiet presence in the room. It hadn't even started to drop needles. But Atticus is not one for half mea-

sures. He took the tree out into the garden and did what had to be done.

He has told me that when it came time for his father to kill the pig he'd raised by hand all year, he'd hire a man to do it, and would leave the house and not come back till the sausage was being made. But Atticus did this deed himself.

After all, the tree had already been cut from its root; its life with us was only a slow dying. A real Christmas tree, a cut tree, is a ritual sacrifice. Better not to deny the fact, but to accept and ponder it.

He saved me some of the dark branches to put in water in a bowl in the front hall. When the trunk dries out it will be good firewood. Next Christmas, maybe.

The Horsies Upstairs

January 2011

ON THE EVE of Christmas Eve the family was all out in the forest where my daughter and son-in-law and three dogs and three horses and a cat live. Three of them live in the horse barn and the pasture at the top of the hill, five of them in the log-cabin-style house at the bottom of the hill, and one of them in great style in a studio cottage with a heating pad all her own, which in winter she deserts only to hunt mice in the woods. That afternoon it was raining, as it had been all December, so everybody was inside, and the kitchen-living-dining room was pretty full of people, the eldest eighty-three and the youngest two.

The two-year-old, Leila, was visiting with her mother and her step-aunt from Toronto. Seven of us had come over for the afternoon, and six were staying there — the hosts upstairs, the Torontans in the study, and one hardy soul out in the trailer. (There is no bed in the studio cottage and Mimi does not share her heating pad.) The dogs were circulating freely among us and there were many good things to eat, arousing much interest in the dogs. For anybody as young as Leila, it must have seemed pretty crowded

and noisy and full of strangers and strangeness, but she took it all in with bright eyes and sweet equanimity.

That morning, when it stopped raining for a while, she had gone up the long, steep driveway with the women to the horse barn and riding ring. They played with pretty Icelandic Perla, and Hank, who stands a stalwart ten hands high and is convinced of his authority as the only horse (as opposed to mare) on the premises. Leila sat in the saddle in front of Aunty Cawoline on Melody, the kind, wise, old cutting horse, and very much enjoyed her riding lesson. When Mel picked up her pace, Leila bounced up and down, up and down, and softly sang "Twot! Twot! Twot! Twot!" round and round the ring.

So then, that afternoon, indoors, at some point among the various conversations, somebody said it would be dark before you knew it. And somebody else said, "Pretty soon we'd better go up and feed the horses."

Leila took this in. Her eyes grew a little brighter. She turned to her mother and asked in a small hopeful voice, "Are the horsies upstairs?"

Her mother gently explained that the horsies were not up in the loft but up in the pasture at the top of the hill. Leila nodded, a little disappointed perhaps, but acceptant.

And I carried her question away with me to smile over and to ponder.

It was both charming and logical. In Toronto, in the limited world of a two-year-old, when somebody talked of going "up," it would almost always mean "upstairs."

And to Leila the log-walled house, which is very tall though not really very large, must have seemed immense, labyrinthine, unpredictable, with its doors and staircases and basement and

loft and porch, everything unexpected, so that you enter the back door at ground level, walk through the house, and go down a long flight of steps to get to ground level . . . Leila had probably been up the loft stairs to the bedroom only once, if at all.

Anything could be up those stairs. Melody, Perla, and Hank could be there. Santa Claus could be there. God could be there.

How does a child arrange a vast world that is always turning out new stuff? She does it the best she can, and doesn't bother with what she can't until she has to. That is my Theory of Child Development.

I wrote a short story once, all of which was true, about going to a conference on the Northern California coast among the redwoods and having not the faintest idea I'd ever seen the place, the cabins, the creek, before—until I was told, and realized it was true, that I'd lived there for two intense weeks of two summers—that this very place was Timbertall, the summer camp my friends and I went to when we were thirteen and fourteen.

At that age, absolutely all I had noticed enough to remember about the location of Timbertall was that we all got on a bus and rode north for hours and hours talking the whole way, and got off, and *were there*. Wherever there was. There was where we were. With the creek, and the cabins, the huge stumps, the high dark trees, and us, still talking, and the horses.

Oh, yes, there were horsies up there too. That's why we were there. That was what mattered, at that age.

I was a kid who, thanks to a wooden jigsaw puzzle of the U.S.A., had the states fairly well located, and had been taught enough geography to acquire some notion of continents and nations. And I knew the redwood country was north of Berkeley, because my parents had driven with me and my brother up

that coast when I was nine, and my father was always clear about compass directions.

And that was all I knew at fourteen about where Timbertall was, and all I cared to know.

I am appalled by my ignorance. Yet it had its own logic. I didn't have to drive the bus, after all. I was a kid, carted around by adults the ways kids are. I had an adequate arrangement of the world, a sufficient understanding of my position, for my needs at the time.

No wonder kids always ask, "Are we there yet?" Because they *are* there. It's just the harried parents who aren't, who have to have all this huge distance between things and have to drive and drive and drive to get to there. That makes no sense to a kid. Maybe that's why they can't see scenery. Scenery is *between* where they are.

It takes years to learn to live between, and thus to get the relationships between things arranged, to make sense of them.

It probably takes the weird adult human mind too. I think animals are where they are in the same way a baby is. Oh, they know the way between places, many of them, as no baby does, and far better than we do—horses for sure, if they've been over the ground once. Bees, if another bee dances it for them. Terns above the trackless ocean . . . Knowing the way, in that sense, is knowing where you are all the way.

At fourteen, unless I was in a very familiar place, I had very little idea where I was. More than Leila, but not that much more.

But at fourteen I knew the horses were not in the loft bedroom. I knew Santa Claus was not at the North Pole. And I was giving a good deal of thought to where God might be.

❧❧

Children have to believe what they are told. Willingness to believe is as necessary to a child as the suckling instinct is to a baby: a child has so much to learn in order to stay alive and in order to be human.

Specifically human knowledge is imparted largely through language, so first we have to learn language, then listen to what we're told and believe it. Testing the validity of information should always be permitted and is sometimes necessary but may also be dangerous: the little one had better believe without running any tests that the stove burner could burn even when it isn't red, that if you eat Gramma's medicine you will be sick, that running out into the street is not a good idea . . . Anyhow, there's so much to be learned, it can't all be tested. We really do have to believe what our elders tell us. We can perceive for ourselves, but have very little instinctive knowledge in how to act on our perceptions, and must be shown the basic patterns of how to arrange the world and how to find our way through it.

Therefore the incalculable value of true information, and the unforgivable wrongness of lying to a child. An adult has the option of not believing. A child, particularly your own child, doesn't.

A scenario: Leila, instead of contentedly accepting the information, begins to wail in disappointment, insisting, "No, the horsies are upstairs! They *are* upstairs!" A softhearted grownup smiles and coos, "Yes, dear, the horsies are upstairs, all cuddled up in bed."

This is a lie, though a tiny, silly one. The child has learned nothing, but has been confirmed in an existential misunderstanding which she'll have to sort out somehow, sometime.

That *up* means up the stairs, up the hill, and a whole lot of

other places too, and that its meaning may depend on where you are at the moment, is important information. A child needs all the help she can get in learning to take that vast variety of meanings into account.

Lying, of course, isn't the same as pretending. Leila and a grownup might have a fine time imagining the horsies in the bedroom, with Hank hogging all the blankets and Perla kicking him and Mel saying, Where's the hay? But for this to work as imagination, the child has to know that the horsies are in fact in the horse barn. In this sense, truth to fact, insofar as we know what fact is, must come first. The child has to be able to trust what she's told. Her belief must be honored by our honesty.

I brought in Santa Claus for a reason. I've always been uncomfortable with the way we handle him. We had Santa Claus in my family (in fact my mother wrote a lovely children's book about Santa Claus in California letting his reindeer graze on the new winter clover). When I was a kid we read "The Night Before Christmas," and we set out milk and cookies by the fireplace, and they were gone in the morning, and we all enjoyed it. People love pretense, and love ritual, and need both. Neither of them is counterfactual. Santa Claus is an odd, quirky, generally benign myth—a real myth, deeply involved in the ritual behaviors of the one great holiday we still have left. As such I honor him.

Very early in my life, like most kids, I could distinguish "Pretend" from "Real," which means I knew myth and fact were different things and had some sense of the no-man's land that lies between the two. At any age I can recall, if somebody had asked me, "Is Santa Claus real?" I would, I think, have been confused

and embarrassed, blushed red in case it was the wrong answer, and said no.

I don't think I missed anything not thinking Santa Claus was real the way my parents were real. I could listen out for reindeer hooves with the best of them.

Our kids had Santa Claus; we read the poem, and left milk and cookies out for him; and so do their kids. To me, that's what's important. That the bonding ritual be honored, the myth reenacted and carried forward in time.

When I was a kid and other kids started telling about "when they found out about Santa Claus," I kept my mouth shut. Incredulity is unlovable. I am opening my mouth now because I am too old to be lovable, but still incredulous when I hear people — adults! — mourning over the awful day they found out that Santa Claus wasn't real.

To me what's awful is not — as it is usually presented — the "loss of belief." What's awful is the demand that children believe or pretend to believe a falsehood, and the guilty-emotion-laden short-circuiting of the mind that happens when fact is deliberately confused with myth, actuality with ritual symbol.

Is what people grieve over the pain not of losing a belief but of realizing that somebody you trusted expected you to believe something they didn't believe? Or is it that in losing literal belief in our fat little Father Christmas, they also lose love and respect for him and what he stands for? But why?

I could go on from here in several directions, one of them political. As some parents manipulate their children's beliefs, however well-meaningly, some politicians play more or less knowingly on people's trust, persuading them to accept a deliberately fostered confusion of actuality with wishful thinking and

fact with symbol. Like, say, the Third Reich. Or Let a Thousand Flowers Bloom. Or Mission Accomplished.

But I don't want to go there. I just want to meditate on the horsies upstairs.

Belief has no value in itself that I can see. Its value increases as it is useful, diminishes as it is replaced by knowledge, and goes negative when it's noxious. In ordinary life, the need for it diminishes as the quantity and quality of knowledge increase.

There are areas in which we have no knowledge, where we need belief, because it's all we can act on. In the whole area we call religion or the realm of the spirit, we can act only on belief. There, belief may be called knowledge by the believer: "I know that my Redeemer liveth." That's fair, so long as it's fair also to maintain and insist upon the difference, outside religion, between the two things. In the realm of science, the value of belief is nil or negative; only knowledge is valuable. Therefore, I don't say I believe two plus two is four, or that the earth goes around the sun, but that I know it. Because evolution is an ever-developing theory, I prefer to say I accept it, rather than that I know it to be true. Acceptance in this sense is, I suppose, the secular equivalent of belief. It can certainly provide endless nourishment and delight for mind and soul.

I'm willing to believe people who say they couldn't live if they lost their religious belief. I hope they'll believe me when I say that if my intellect goes, if I'm left groping in confusion unable to tell the real from the imagined, if I lose what I know and the capacity to learn, I hope I die.

To see a person who's lived only two years in this world seeking and finding her way in it, perfectly trusting, having her trust rewarded with truth, and accepting it—that was a lovely thing

to see. What it made me think about above all is how incredibly much we learn between our birthday and last day—from where the horsies live to the origin of the stars. How rich we are in knowledge, and in all that lies around us yet to learn. Billionaires, all of us.

First Contact

May 2011

I HAVE SEEN many rattlesnakes, I have eaten fried rattlesnake; but only once have I ever been in contact with a living rattler. Though *contact* is not the word I really want—it is metaphorical and inexact. We did not touch. Maybe it was communication, though of a very limited kind. As communication between alien species is perhaps doomed to be.

I have told the story often as a comedy, a story in which people behave ridiculously, with a happy ending. Here it is:

We were at the old ranch in the Napa Valley and I was just about to sit down on one of the 1932 iron chaise lounges (carefully, because if you sit too far toward the end, the whole unwieldy thing stands up and throws you off like a bronco) when I heard a noise I recognized. That was the first communication. It was the hissing buzz of the rattlesnake's rattles. Startled by my movements, it was heading off into the high grass, rattling away. About fifteen feet away it looked back, saw me looking at it, and stopped there, its head up and facing me and its gaze fixed on me. As mine was fixed on it.

I hollered for Charles. The rattler paid no attention. I believe

they are deaf. I suppose they "hear" their own rattle as vibration in their body, not in the air.

Charles came out and we discussed the situation — not calmly. I said, "If he goes off into the high grass there, we'll never dare walk out in the pasture the whole time we're here."

We thought we had to kill the rattlesnake. That's what you do, generally, in the country, at a place where little kids come and run around.

Charles went and got the big heavy long-handled hoe my father called the Portugee hoe, with which rattlers had been killed before, by others. Not by us. Charles got close enough to strike.

The rattler and I had never taken our eyes off each other, or moved.

Charles said, "I can't."

I said, "I couldn't either."

"So what do we do?" we said.

The rattler was probably thinking the same thing.

"Go see if Denys is there?" Charles said.

I said, "I don't think it'll move so long as we keep staring at each other, so you go."

And Charles went up the driveway and down the road a couple hundred yards to our only near neighbors, the Cazets. It took a while. All that while, the snake and I did not move and looked steadily into each other's eyes. They say a snake's gaze is hypnotic, but who was hypnotizing whom?

We were like people newly in love who "can't take their eyes off each other." This was not love, but it was something equally intense, and even more immediately a matter of life and death.

It is this brief time, five or six minutes I suppose, ten minutes at most, that over the years I have thought of again and again, always with the vividness of the moment and always with a sense

of its importance, or import: of there being a great deal to learn from it.

During this time, the rattlesnake and I were alone together. Alone in all the world. We were held together by common fear—bonded. We were held in a spell—entranced.

This time was outside ordinary time, and outside ordinary feelings; it involved danger for both of us; and it involved a bond between creatures who do not and cannot ordinarily relate to each other in any way. Each would naturally try *not* to relate—to just get away—or to kill in self-defense.

In all these respects, I think it isn't amiss to think of this time as sacred.

The sacred and the comic are not that far apart, something the Pueblo Indians seem to know better than most of us do.

Charles and Denys came panting down the driveway with the big galvanized garbage can and a piece of semirigid white plastic tubing about fifteen feet long. Denys had the tube; he knew what to do because he'd done it before. A distinguished artist/author of children's books, he was a year-rounder in the valley. And his house was on a pretty little property which, before the house was built, we used to call Rattlesnake Clearing.

The snake continued to look at me only and I at it only, while Denys set the garbage can down on its side with the opening facing the snake, maybe twenty feet from it and very visible to it. Then, coming quietly round behind it at full tube-length, he flicked the end of the tube near its head. That broke the spell. I looked away from the snake at the tube, the snake looked away from me at the tube, and then flowed hurriedly away from the thing flicking about in the air behind it and made straight for the welcoming dark cave of the garbage can. It flowed right into it —at which Charles ran to upend the can, and clapped the lid on.

A mighty and wrathful commotion took place inside the can. It shivered and trembled and all but danced. We stood in awe and listened to the rage of a truly angry rattlesnake in an echo chamber. It finally quieted down.

"Now what?"

"Anywhere a good ways away from the house."

"There's the millionaire up at the end of the road," said Denys. "I've turned several snakes loose up there."

A pleasing thought. The millionaire was never there, nobody lived on his lovely hilltop. Excellent rattlesnake territory. The three humans and the garbage can all got in the car and drove up the road, the snake in the can making some vicious criticisms in a low, hissing buzz along the way. At the end of the road we got out and laid the can down, knocked the lid off with the invaluable plastic tube, and watched the split-second disappearance of the snake into a thousand acres of wild oats.

It was our garbage can, the one that still stands up at the top of the driveway where the garbage company can collect on Mondays. I have never looked at that can since, in all these years, without thinking of what it held, once.

A teaching, a blessing, may come in strange ways, ways we do not expect, or control, or welcome, or understand. We are left to think it over.

The Lynx

November 2010

LAST WEEK MY friend Roger and I went out to Bend, the eastern Oregon city where a lot of retired people in search of sunlight and a dry climate have been settling since the 1990s. From Portland the shortest road is over Mount Hood and through the vast Warm Springs Reservation. It was a bright late October day, with the big broadleaf maples making masses of pure gold in the evergreen forests. The blue of the sky got more intense as we went down from the summit into the clear air and open landscapes of Oregon's dry side.

Bend is named, I guess, for the bend of its lively river in which it sits. The Three Sisters and other snow cones of the Cascades tower up over it in the west, and the vast expanses of the high desert sweep on out eastward. In recent years the city grew and thrived with the influx of settlers, but it hit hard times with the recession. Too much of its prosperity depended on the construction trades. Downtown is still pleasant, but there are gaps, with several fine restaurants gone, and it looks as if some new resorts out toward Mount Bachelor are paralyzed at the platting stage.

We stayed at a motel there on the west side of the river, which

is built up at intervals, with bits of juniper forest and sagebrush plain in between. The long, wide boulevards go winding around in curves, crisscrossing each other at three- and four-exit round-abouts. It appears that the people who laid out the roads wanted to imitate what happens when you drop noodles on the floor. Though Tina at Camalli Books had given us careful instructions with all the road names and all the roundabout exits on the way to and from our motel—and though a western skyline of six- to ten-thousand-foot mountain peaks would seem to provide ad-equate orientation—we never once left the motel without get-ting lost.

I learned to dread the Old Mill District. As soon as I saw the sign saying OLD MILL DISTRICT I knew we were lost again. If Bend were a big city instead of just a far-flung one we might still be there trying to escape from the Old Mill District.

Roger and I were there to do a reading and signing of our book *Out Here* at the bookstore Friday evening and at the High Desert Museum Saturday afternoon. The museum is on High-way 97 a few miles south of town. A bit farther on is Sunriver, one of the earliest and biggest resort developments. Roger sug-gested we have lunch there. Given the money that flows through those residential resorts, I was expecting something on the gour-met side; but the bar and grill served the same huge piles of heavy food that you get at a bar and grill anywhere in America, where the idea of a light lunch is a pound or two of nachos.

I haven't stayed at Sunriver but have spent a few nights at other high-end resorts in the area. They are laid out artfully to blend into the austere and beautiful landscape. Built of wood and painted or stained in a repetitive range of muted colors, the houses are unobtrusive, with plenty of space around them and trees left standing between them. All the streets curve. Straight

streets are anathema to the resort mind. Right angles say City, and resorts are busy saying Country, and that's why all the boulevards west of the river loop and swoop about so gracefully like noodles. The trouble is, since the juniper trees and the sage bushes and the buildings and the streets and the boulevards all look pretty much alike, if you don't remember just where Colorado Drive connects with Century Drive before the roundabout exit to Cascade Drive, if you don't have a good inner or external GPS system, you get lost.

Staying a couple of years ago at one of these resorts in a granny flat in somebody's condo, I could get lost within a hundred yards of the house. All the curvy streets and roads were lined with groups of houses in tasteful muted earth tones that exactly resembled the other groups of houses in tasteful muted earth tones, and there were no landmarks, and it all went on, over and over, sprawling out, without sidewalks — because of course the existence of such a place is predicated entirely on driving, on getting to it, from it, and around it by car. I don't drive.

Bend is, I believe, the largest city in America with no public transportation system. They were fixing to do something about that when the bottom fell out of the building trade.

So after getting lost a couple of times walking, because I couldn't tell which tastefully muted house on which curving road was my house, I was uneasy about going out again. But if granny didn't go for a walk she was trapped in the granny flat. And that was pretty bad. When you first walked in, you thought, Oh! very nice! — because the whole inner wall was a mirror, which reflected the room and the big window, making it look large and light. In fact the room was so small it was almost entirely filled with bed.

The bed was piled with ornamental pillows. I counted

them, but have forgotten how many there were—say twenty or twenty-five ornamental pillows, and four or five enormous teddy bears. When you took the bears and pillows off the bed so you could use the bed, there was no place to put them but on the floor around the bed, which meant there was no floor space, only pillows and bears. There was a tiny kitchen on the other side of a divider. No desk, no chair, though there was a blessed window seat to sit in, with a big view of trees and sky. I lived in the window seat, making my way through the bears and pillows when it was time for bed.

A door, which could not be locked, led down a corridor to the owners' apartment, which was occupied. I put my suitcase and eight or ten of the pillows and the hugest, most obese teddy bear against the door as a barrier against absent-minded intrusion by my unknown hosts. But I didn't have any real faith in that bear.

Roger and I kept passing that very resort on our noodly way to refinding our motel, and I winced every time I saw it, afraid we might somehow get into it and get lost in it again.

I feel vaguely guilty about preferring a mere motel to a carefully planned, upscale residential resort. But the guilt is vague while the preference is clear and categorical. I like motels. Exclusivity isn't my bag. "Gated communities" are not communities in any sense of the word I understand. I know that a great many of the people who own or time-share or rent places in these dry-side resorts go there not for the exclusive company of other middle-class white people but for the marvelous air and light of the high desert, the forests, the ski slopes, the spaciousness and silence. I know. That's fine. Just don't make me stay in one. Especially not one equipped with giant teddy bears.

But all this is merely preparation for getting to the lynx.

The lynx lives at the High Desert Museum. Briefly, when he was a kitten somebody pulled out his claws ("declawing" a cat is the same as pulling out a human being's fingernails and toenails or cutting off the last joint of each toe and finger). Then they pulled out his four great cat fangs. Then they pretended he was their itty-bitty kitty. Then they got tired of him, or got scared of him, and dumped him. He was found starving.

Like all the birds and animals at the High Desert Museum, he is a wild creature who can't survive in the wild.

His cage is inside the main building. It is a long enclosure with three solid walls and one glass wall. It has trees and some hiding places, and is roofless, open to the weather and the sky.

I don't think I'd ever seen a lynx when I first met him. He is a beautiful animal, chunkier and more compact than a mountain lion. His very thick dense fur of a honeybuff color has a flowing scatter of dark spots on legs and flanks and goes pure white on belly, throat, and beard. Big paws, ever so soft-looking, but you wouldn't want to be at the receiving end of one of those paws, even if its fierce, hooked weaponry has been torn out. Short tail, almost a stub—when it comes to tail, the mountain lion has it all over the lynx and bobcat. Lynx ears are rather queer and charming, with a long tip; his right ear is a bit squashed or bent. A big squarish head, with the calm, enigmatic cat smile, and great gold eyes.

The glass wall doesn't look like one-way glass. I've never asked about it. If he is aware of the people on the other side of the glass, he doesn't let them know it. He gazes out sometimes, but I have not seen his eyes catch on anything or follow anyone on the other side of the glass. His gaze goes right through you. You are not there. *He* is there.

I found and fell in love with the lynx during the last evening

of a literary conference a couple of years ago. The writers at the meeting had been invited to a banquet at the museum to meet and mix with people who supported the conference with donations. This kind of thing is a perfectly reasonable attempt to reward generosity, though, knowing what writers are like, it must often be terribly disappointing to the donors. It is also an ordeal for many of the writers. People like me who work alone tend to be introverts and, indeed, uncouth. If *piano* is the opposite of *forte*, graceful chitchat with strangers is definitely my *piano*.

During the hour of wine and cheese before dinner, all the donors and writers milled about the main hall of the museum, talking. Being no good at milling and talking, and noticing a corridor off the main hall with no people in it, I sneaked off to explore it. First I found the bobcat (who must wake up now and then, though so far I have only seen him asleep). Then, getting farther away from the chatter of my species, going farther into dimness and silence, I came on the lynx.

He was sitting gazing out into the dimness and silence with his golden eyes. The pure gaze of the animal, Rilke called it. The gaze that is purely gaze: that sees *through*. For me, at that moment of feeling inadequate and out of place, the unexpected, splendid animal presence, his beauty, his perfect self-containment, was refreshment, consolation, peace.

I hung out with the lynx until I had to go back to the Bandar-log. At the end of the party I sneaked back for a moment to see him again. He was sleeping majestically in his little treehouse, great soft paws crossed in front of his chest. I had lost my heart for good.

I saw him again last year when my daughter Elisabeth drove me around eastern Oregon for four days (a grand trip, of which

I hope to put a record in words and pictures on my site, if Elisabeth and I can goad each other into getting it together). She and I saw the displays and the otters and the owls and the porcupine and everything else at the museum, and ended in a long contemplation of the lynx.

And last week, before the reading, while Roger was doing all the hard work getting the books to sign into the museum, I could spend another half hour with him. When I came, he was pacing about, very handsome and restless. If he had a tail that was worth lashing he would certainly have been lashing it. After a few minutes he vanished through a big metal cat flap into some kind of back room not on view to the public. Fair enough, I thought, he wants some privacy. I went on to look at the live butterfly exhibit, which of course was lovely. The Oregon High Desert Museum is one of the most perfectly satisfying places I know.

When I came back down the corridor the lynx was sitting quite close to the glass, eating a largish bird. A grouse, was my guess. At any rate a wild bird, not a chicken. He had a tail feather hanging down from his chin for a while, which might have reduced his dignity in the eyes of beholders, but he does not acknowledge beholders.

He worked at his bird with diligence and care. He *discussed* his bird, as they used to say of people eating lamb chops. He was quite absorbed in discussing it. Lacking all four fangs, he was pretty much in the position of a human lacking incisors: he had to go at it sideways, with his molars. He did this neatly. It slowed him down, I am sure, but he never grew impatient, even when all he got was a mouthful of feathers. He just put a big soft honey-colored paw on his lunch and went at it again. When he got seriously inside the bird, some children who came by squealed,

"Eeeyew! He's eating the insides!" and some other children who came by murmured with satisfaction, "Oh look, he's eating the guts."

I had to go away then and do the reading and signing, so I could not see him finish lunch.

When I came back after an hour or so for a goodbye glimpse, the lynx was curled up comfortably asleep in his treehouse bedroom. One wing and a beak lay on the dirt near the glass wall. On three tree stumps, the servants of the lynx had laid out three dead mice—an elegant dessert presentation, as the fancy restaurants say. I imagined that later, when the museum closed, when all the primates had finally gone away, the big cat might wake up and yawn, and stretch himself lithely down from his treehouse, and eat his desserts one by one, slowly, in silence, all by himself in the darkness.

There is a connection that I am groping for, a connection between the resorts and the lynx. Not the noodly streets that took us from one to the other, but a mental connection that has something to do with community and solitude.

The resorts are neither city nor country; they are semi-communities. Most of their population is occasional or transient. The only day workers are gardeners, janitors, people doing upkeep. They don't live in the nice houses. Most of the people that do are there not because their work takes them there but to get away from their work. They're not there because they have common interests with others there but to get away from other people. Or to pursue sports such as golf and skiing, which pit the individual against himself. Or because they long for the solitude of the wilderness.

But we aren't a solitary species. Like it or not, we are the Bandar-log. We are social by nature, and thrive only in community. It is entirely unnatural for a human being to live long completely alone. So when we get sick of crowds and yearn for space and silence, we build these semi-communities, pseudo-communities, in remote places. And then, sadly, by going to them, swarming into the desert, all too often we find no true community, but only destroy the solitude we sought.

As for cats, most of their species are not social at all. The nearest thing to a cat society is probably a troop of active lionesses providing for the cubs and the indolent male. Farm cats sharing a barn work out a kind of ad hoc social order, though the males tend to be less members of it than a danger to it. Adult male lynxes are loners. They walk by themselves.

The strange fortune of my lynx brought him to live in an artificial environment, a human community utterly foreign to him. His isolation from his natural, complex wilderness habitat is grievous and unnatural. But his aloofness, his aloneness, is the truth of his own nature. He retains that nature, brings it among us unchanged. He brings us the gift of his indestructible solitude.

Notes from a Week at a Ranch in the Oregon High Desert

August 2013

THE HOUSE WHERE we stay is on a small cattle ranch, in the valley of a creek that comes energetically down off a mountain, cutting a winding oasis of willows and grass between very steep ridges topped with basalt walls like battlements—rimrock. Across the creek is the ranchhouse under a huge old weeping willow. The eastern ridge rises immediately behind it; immediately behind our house, the western ridge. Level, grassy pastures fill the narrow land between; the steep slopes are sagebrush, rabbitbrush, bare dirt, rock. Far up the long valley, most of the ranch stock are still in summer pasture. It's very quiet around the house. The nearest town is three miles to the north. Its population this year is five.

ON THE FIRST DAY

Five swallows sit the near wire.

A fiercely agitated flicker lights on the other wire, then follows its own crackling cry.

Rain hangs in the overcast, heavy above the ridge.

A hen has laid an egg: outbursts of proud contentment. Two roosters crow, competing.

The peacocks make their gallant, melancholy, meowing trumpet call.

Soon the sun will break above the rimrock of the ridge, an hour after rising.

Flights of blackbirds pass in the cool, shadowed air between the eastern and the western rimrock, dozens at a flight, each flight a sound of many wings, an airy throbbing rush and thrill. The creaking whicker of wind in feather, now and then. Now and then a chirp.

In silence far above them swallows follow the hunt, the least and sweetest predators.

A contrail feathers out white over the eastern ridge.

As my eyes begin to have to look away from the slow intolerable brightening I close them and inside the lids see the long curve of the ridge dark red, the darkest red: above it a band of green, the purest green. Each time I look and close my eyes again, the band of green grows wider, burning clear, unmitigated fire of emerald. Then at its center appears a circle of pale, unearthly blue.

I open my eyes and see the source, the sun, one glance, and look down blinded, humble, to the earth, the dull black lava pavement of the path.

The warmth of the sun is on my face as soon as its light is.

❧❧

After the tremendous thunderstorm of afternoon, tall shivering towers of rain that swept across the pastures, wind that writhed the great old willow like seaweed in the waves, after all that was over and the quiet dusk was filling up the air between the ridges, the horses got to frisking. The little roan and the three bays nipped and kicked, ran and reared, chest to chest; even Daryll, old paint swayback boss, got into it with the colts a bit. They teased, they galloped across the pastures, hooves drummed that wild music on the ground. They quieted down, drifting off north along the creek. Old paint's white flank glimmered like fireflies in the willowy dark.

In the night, awake, I thought of them standing in the wet grass, among the willows, in the night.

I stood on the doorstep in the deep night. Cloud-veils crossed the blazing pavement of the firmament and passed. Above the eastern ridge a shining blur, the Pleiades.

On the Second Night

On the second night all creatures woke, and the sleepless cricket was silent suddenly. The thunder spoke from ridge to ridge, from canyon to canyon, far, then nearer. Darkness split wide open to reveal what it hides. Only for a moment can the eyes of the creatures see the world in that awful light.

On the Third Day

In the afternoon the ravens of the western ridge flew with their children across the air between the ridges, calling in their language full of r's. The youngest talked a lot, the elders answered

briefly. Then all at once there seemed to be five ravens? six?—no: these were vultures, materializing from the sky, eleven, twelve, nine, seven ... soaring, vanishing, appearing, circling, playing with heights and distances and one another in their marvelous, calm, and never broken silence.

After a while they all drifted off back south toward the mountain, quiet lords of the warm towers of the air.

Walking up the road from Diamond after dinner, we heard way off across the fields the shrill, uncanny chorus, a coyote family. A nighthawk's twang. Metal rattled loud where a hoof touched it in the effortless leap: the doe flitted off into twilight like a rolling-falling wave. Then, from the old, tall poplars hoarding darkness, voices spoke softly with complete authority. Under cloud, the red sun shone out, sank, was gone. The owls said nothing more. The old trees released their darkess finally.

ON THE MORNING OF THE FOURTH DAY

Sunlight fills the open valley half a mile away, but here between the rimrocked ridges I sit in windy shadow; half an hour yet to wait on the lava doorstep, while the rain from yesterday's thundershower drips from gutterless eaves onto my head and book, for the brightness over the dark bulk of the ridge to gather and center into the sun itself.

The big black cattle munch industrious on rain-gift grass just outside the wooden fence around the house. A peacock pulls his poor, slattern tail along through molting August, pride reduced to sapphire head and rajah's crest and the brassy, meowing, melancholy jungle cry.

The banty rooster shrills: It-is-a-clarion-call! It-is-a-clarion-call! The big rooster exerts the unjustified superiority of a deeper voice. The hens pay no attention, scattering out, scudding along like sailboats over the grass. Now they begin to chatter, to gather back to the henyard: Gretchen has come out to scatter feed.

The contrail shines where it has each morning, drifting now steadily north and east to where the sun will rise. It slowly passes, iridescent, behind the ridge that darkens as the brightness grows.

It is risen. It is risen in beauty.

The reliable miracle, a couple of minutes later and a little farther south each day.

The lesser miracle, the brief transubstantiation of black lava into glimmering red-violet and blue-green light in my observing and delighted eyes, has occurred, is over. The rough black rock keeps its secret.

The daily hummingbird assaults existence with improbability. He is drawn to my orange tea mug.

The big black heavy cattle munch and breathe and gaze, each with its following of small black birds. All living things work hard to make their living.

I sit on the rough black steps and try to tell the secret that they keep. But I cannot.

They keep it.

In Molt
The peacock walks away
in pace of ceremony: step, and pause:
step, and pause:
a king to coronation, or beheading.
The single remnant of his glory
stripped bare, bone white,
trails behind him in the dirt.

❧❧

On the Fifth Afternoon

Hundreds of blackbirds gathered in the pastures south of the house, vanishing completely in the tall grass, then rising out of it in ripples and billows, or streaming and streaming up into a single tree up under the ridge till its lower branches were blacker with birds than green with leaves, then flowing down away from it into the reeds and out across the air in a single, flickering, particulate wave. What is entity?